The DC Comics o

WRITING

Comics

PAGE ONE

KICKER: The Arrow and the Bat: Part 1

TITLE: The Meeting

FULL PAGE SHOT: GA, IN FULL SUPERHERO COSTUME, HAS T FULL RAW,
IS AIMING AN ARROW AT US. HE LOOKS GRIM AS HELL.
NEXT PAGE, WE'LL SEE THAT

WE'RE IN THE DIMLY-LIT HALLWAY OF A TENEMENT.

CAPTION: Two weeks ago:

GA: Drop it.

GA: [2nd, electric] Now!

Introduction by Stan Lee

The DC Co

W

ACKNOWLEDGMENTS

I've learned from dozens of people, perhaps hundreds. I wish I could remember and acknowledge every one of them. But I can't. Below, a few who I *can* remember and whose help has been particularly valuable in preparing this book.

In no particular order: Scott Peterson, Jordan B. Gorfinkel, Devin K. Grayson, Stan Lee, Julius Schwartz, Greg Rucka, Darren Vincenzo, Alan Grant, Chuck Dixon, Doug Moench, Lawrence O'Neil, Joe Illidge, Kelley Puckett, Will Eisner, Larry Hama, Jack C. Harris, Mark Gruenwald, Dick Giordano, Paul Levitz, Archie Goodwin and, as always, Mari.

Although you may not be aware of it, you helped me write these pages and I'm grateful to you all.

SHE DIED.

MASTER BRUCE--

CONTENTS

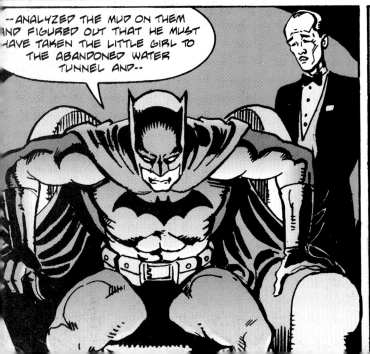

--ANALYZED THE MUD ON THEM AND FIGURED OUT THAT HE MUST HAVE TAKEN THE LITTLE GIRL TO THE ABANDONED WATER TUNNEL AND--

--I WAS RIGHT.

BUT I WASN'T STRONG ENOUGH.

TO GET UNDER --

SISSY?

INTRODUCTION

I know of no one more qualified to write a book about writing for comics than Denny O'Neil—and hey, I know a lot of people.

One of the most impressive things about Denny (nobody calls him Dennis except those who don't like him, and they don't exist) is the fact that he's done it all. In addition to his comic book writing and editing, he's penned short stories and articles for such a wide variety of publications as *Gentlemen's Quarterly, Ellery Queen Mystery Magazine, New York, The Village Voice* and *Publishers Weekly,* among countless others.

Now you'd think that would be enough for any writer, right? Wrong! Dynamic Denny has also had five teleplays produced, done comic book versions of the four Batman movies, and is the author of several novels and nonfiction books. His book, *Knightfall,* published by Bantam, which converted 1,162 pages of comic book continuity in a hardcover novel, became a national bestseller—during which time Denny also assisted BBC Radio with an adaptation of the book's story line.

I could go on and on, and since I'm such a big fan of his, I will.

Proving he knows whereof he writes (not that any additional proof can possibly be needed), he has taught writing at the School of Visual Arts in Manhattan and lectured at dozens of colleges and universities. In fact, by the time you read these imperishable words, he'll probably have started teaching his course in comics at Sarah Lawrence College.

So, when Dynamic Denny tells you how it is, you can take that to the bank, Bunky—that's how it is!

But everything I have to say about Denny isn't good. Here's the bad part . . .

In the 1960s he worked at Marvel Comics as my editorial assistant. He wrote and edited a lot of great stuff for us, but then, I guess because he figured DC Comics needed him more than we did, he left our bullpen and ended up at the bastion of Batman, the shrine of Superman, and the gate of the Green Lantern. To clobber you with an old cliché, our loss was most definitely DC's gain.

But the things I've enumerated so far are just facts and statistics. I'd like to give you an insight into the real Denny O'Neil, to help you realize why he's so eminently qualified to write a book like this.

One prime example comes to mind. In 1970 Denny wrote one of his many exciting Green Lantern scripts. It was issue #76, and it was destined to become a true

classic. Illustrated by the gifted Neal Adams, the story plot had the Green Lantern talking to a black man in the ghetto of a large city. It was there that Denny penned a passage which has been quoted and requoted, printed and reprinted countless times in countless languages; a passage that so clearly proves why Denny O'Neil is one of the finest writers in comic books—or indeed, in any type of books.

Not to keep you in suspense any longer, Denny has the black man saying to the Green Lantern, "I been readin' about you . . . how you work for the blue skins . . . and how on a planet someplace you helped out the orange skins . . . and you done considerable for the purple skins! Only there's skins you never bothered with--! . . . the Black skins! I want to know . . . how come?! Answer me that, Mr. Green Lantern!!"

The Green Lantern can only reply, "I . . . can't . . ."

In a few short sentences, Denny managed to say volumes. With quotes such as those and the many, many other thought-provoking tales he has written, Denny helped to lift comics out of the category of "little kid stuff" and endow them with substance and intelligence, thus bringing them into the realm of true literature.

Well, if I keep lauding him so much you might think I'm trying to sell you something. Although, come to think of it, I guess I am. I'm trying to sell you on the fact that Denny O'Neil is one of the finest practitioners of his art. He's a writer's writer, a professional's professional, and for those of you who genuinely want to learn how comics are written, you couldn't find a better guide.

In fact, I'm gonna end this exotic little essay right now because I can't wait to join you in reading the pages that follow.

So let's both get to the good stuff, secure in the knowledge that with Denny O'Neil at the helm, we're in very good hands.

Excelsior!

Stan Lee

PART ONE

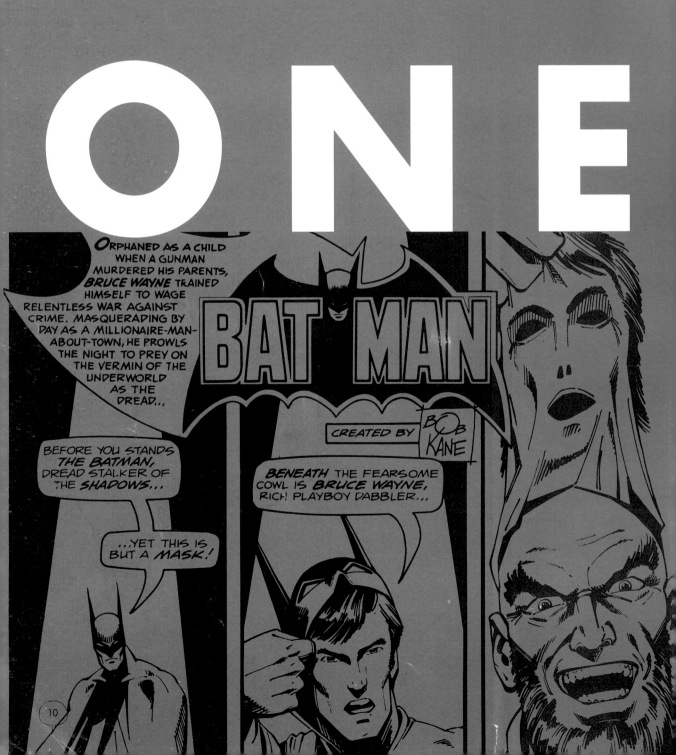

ORPHANED AS A CHILD WHEN A GUNMAN MURDERED HIS PARENTS, *BRUCE WAYNE* TRAINED HIMSELF TO WAGE RELENTLESS WAR AGAINST CRIME. MASQUERADING BY DAY AS A MILLIONAIRE-MAN-ABOUT-TOWN, HE PROWLS THE NIGHT TO PREY ON THE VERMIN OF THE UNDERWORLD AS THE DREAD...

BAT MAN

CREATED BY BOB KANE

BEFORE YOU STANDS *THE BATMAN,* DREAD STALKER OF THE *SHADOWS...*

BENEATH THE FEARSOME COWL IS *BRUCE WAYNE,* RICH! PLAYBOY DABBLER...

...YET THIS IS BUT A *MASK!*

10

Here's what I'd like you to do for me:

Make me laugh. Make me cry. Tell me my place in the world. Lift me out of my skin and place me in another. Show me places I have never visited and carry me to the ends of time and space. Give my demons names and help me to confront them. Demonstrate for me possibilities I've never thought of and present me with heroes who will give me courage and hope. Ease my sorrows and increase my joy. Teach me compassion. Entertain and enchant and enlighten me.

Tell me a story.

That's what this book is about—the telling of stories in an odd and wonderful form called "comics." In the pages that follow, I'll discuss the writing of comic books. I'll explain, as well as I can, everything I've learned in over thirty years of doing this work, both as a writer and an editor, with the hope that when you finally reach the end you'll have everything you need to begin producing successful scripts.

And then you'll be a comic book writer?

Well, no. I can't teach you to be a writer—of comics or anything else. What I can try to do is give you tricks and techniques that would have been useful to me when I was struggling with my first assignments. After that, you'll be at the beginning. Then, by writing and writing and writing some more, you'll gradually begin to teach yourself, and the real learning process will start. If you're lucky, it will never end. And if you discover that "writing and writing and writing some more" is unbearably tedious, you may decide this is not an effort you should be making. That kind of information can be a treasure.

Before we delve into those tricks and techniques, it might be useful to ask a basic question. Our goal, remember, is to tell stories. So, just exactly what is a story?

Here is the best one-sentence definition I've ever found:

A story is structured narrative designed to achieve an emotional effect, demonstrate
a proposition, or reveal character.

Keep that in mind; we'll return to it often. But now, let's ask another basic question.

WHAT ARE COMICS?

They are not a collection of words and images printed on the same page. (That's what illustrated books are.) To be a comic book, those words and images must work together as parts of speech work together in a normal English sentence. Think of comics as a language comprised of two separate and vastly different elements used in tandem to convey information. To be a good comics writer, you must be, or become, as fluent in this hybrid language as you are in your mother tongue.

Writing comics is a bit like writing poetry; you've got to adapt your thoughts to a fairly rigid form and use it so fluently that readers are unaware of its artificiality.

Before we discuss the words part of the words-and-pictures alliance, let's look at the basic "vocabulary" of our language—terms which apply only to comics.

Comic Book Terminology

Story page or page: One comic book page, which may be more or less than one manuscript page.

Manuscript page: Page in your script.

Splash page: Usually the first page, with one or two images, incorporating title, logo (if any), credits, other such information. Placing the splash page later in the story, on page two, three, or even four, is becoming common. It is a questionable practice because, in the minds of some readers, the story doesnt *really* start until they've read past the credits and title. Once, a long time ago, I used a lot of page two splashes. I now wish I hadn't. I did it for the sake of novelty, and that's not a sufficiently good reason. If a technique has no direct, discernible narrative benefit, question it, hard; using it might not be doing your audience any favors.

If there will be more than one story in the issue, it's a very good idea to treat the splash page as a second cover, featuring the character's name/logo, title and credits to signal the reader that he or she is into a new story. (In fact, that's almost certainly why the splash-page convention began. Once upon a time, believe it or not, *all* comics had more than one story.)

The term "splash page" is often misused when a writer really means a full-page shot.

Full-page shot: One page, one picture.

Panel: One box (which is what some older writers called it). Usually, one picture, also known as a shot.

With this old-fashioned splash page, a bit copy-heavy, the intention was to set a mood rather than draw the reader directly into the action. This approach makes the splash, in effect, a second cover and is especially useful when the comic contains more than one story. From *Detective Comics* #457.

BATMAN

TWENTY-ONE YEARS AGO, THIS NEIGHBORHOOD WAS THE DWELLING PLACE OF THE RICH AND SOON-TO-BE RICH... A PLACE OF GOURMET RESTAURANTS AND FASHIONABLE THEATERS... OF ELEGANT WOMEN AND SUAVE MEN...

BUT THE DRY ROT OF TIME SET IN, AND THE LAUGHTER STOPPED AND THE LIGHTS DIMMED, AND THOSE ELEGANT WOMEN AND SUAVE MEN SOUGHT THEIR PLEASURES ELSEWHERE... AND NOW, ONLY THE FORLORN AND THE DESPERATE WALK THESE STREETS...

FOR ONE NIGHT, TWO BRUTAL SLAYINGS OCCURRED SIGNALING THE BEGINNING OF THE END... THE AREA KNOWN AS *PARK ROW* ACQUIRED A *NEW* NAME -- *CRIME ALLEY*... AND --

S-2177

"THERE IS NO HOPE IN CRIME ALLEY!"

Story by
DENNY O'NEIL
Art by
DICK GIORDANO
Edited by
JULIUS SCHWARTZ

Shot: One picture, but with connotation of the content of picture, the way it is composed, etc. More an aesthetic/storytelling term. Terms used to describe a shot include closeup, long shot, medium shot, extreme closeup, etc.

While we're on the subject of panels and shots: One of the most obvious beginners' mistakes is also one of the most common, that of asking the artist to draw two or more actions in a single panel. Since that's impossible, it's not a good idea to ask your penciller to do it. Using speed lines and multi-image shots (discussed below) you can *suggest* movement and multiple actions but these devices are somewhat awkward, perhaps best used sparingly.

```
KINGDOM COME #2: "Truth and Justice"/Ms. Page 2 /REVISED 2/7/96!/MARK WAID

                              PAGE TWO

    PANEL ONE:  PULL BACK FROM PREVIOUS IMAGE TO SHOW THAT THE BLACK
    BACKGROUND IS ACTUALLY THE CORNEA OF McCAY'S OPEN EYE.  NO
    DIALOGUE.

    PANEL TWO:  PULL BACK FURTHER TO SHOW McCAY'S FULL FACE--WIDE-
    EYED WITH HORROR.

    1 CAP:          "...to sound..."

    PANEL THREE:  PULL BACK FURTHER TO SHOW McCAY FULL-FIGURE,
    STANDING IN WHATEVER MISTY, TIMELESS SPECTREVOID HE AND SPECTRE
    HANG OUT IN BETWEEN ISSUES.  SWIRLY WITH COLORS?  DOESN'T MUCH
    MATTER TO ME.  YOUR CALL.  REALLY.  ANYWAY, SPECTRE STANDS BESIDE
    AND SLIGHTLY BEHIND McCAY, STARING DOWN AT HIM.

    2 CAP:          ...angels...

    3 CAP:          ...no...I'M with the ANGEL...

    4 CAP:          ...aren't I...?

    PANEL FOUR:  WHILE HOLDING THE EDGE OF HIS CAPE, SPECTRE RAISES
    ONE ARM HIGH, SPREADING THE CAPE WIDE TO REVEAL A BLACK VOID
    WITHIN.

    5 McCAY:        Where have you TAKEN me?  I no longer have any
                    sense of TIME or PLACE...

    6 SPECTRE:      Time has LITTLE MEANING where we walk, Norman
                    McCay.  We move FREELY from MOMENT to MOMENT.

    7 SPECTRE:      GUIDED by YOUR VISIONS, I show you only that which
                    we MUST see.

    8 SPECTRE:      You are DISORIENTED?

    9 McCAY:        ENORMOUSLY.  I wasn't really ASLEEP...and yet, I
                    was DREAMING again...

    PANEL FIVE:  AS WE MOVE IN ON THE BLACK SHADOW UNDER SPECTRE'S
    CAPE, WE BEGIN TO SEE IN THAT BLACKNESS A HAZY IMAGE OF NEXT
    PANEL'S ESTABLISHING SHOT.

    10 SPECTRE:     WERE you...?
```

Mark Waid's script for *Kingdom Come* #2 provides clear, concise shot descriptions and still, as in panel three, gives the artist some latitude in interpretation. Art by Alex Ross.

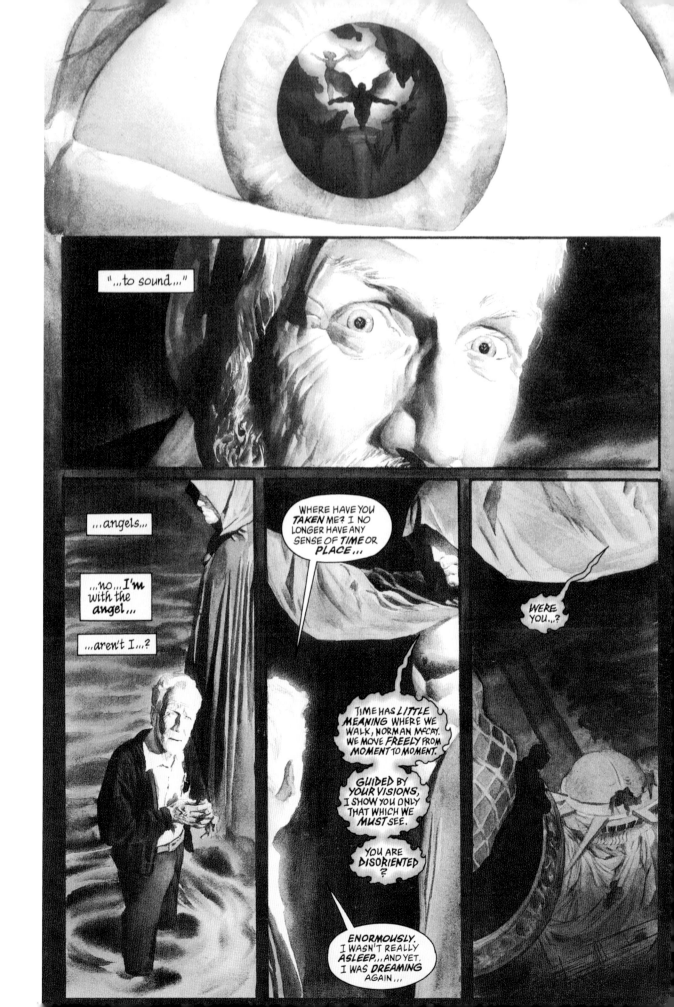

Speech balloon, word balloon or balloon: The thing containing words that lets the reader know what the character is saying.

Pointer or tail: The thing that sticks out from the balloon and points to whichever character is talking.

Thought balloon: A scalloped balloon that indicates the character is thinking, rather than speaking aloud. (Early comics did this by putting some of the words in the balloon in parentheses.) Instead of pointers, thought balloons have little bubbles trailing from the balloon to the general vicinity of the character's head.

Burst: A balloon with jagged edges to indicate volume/stress or broad-cast/telephone transmission. Also called electric or electric balloon.

Whisper balloon: A balloon whose outline is broken into small dashes; this indicates that the character is whispering. Another way to indicate a whisper, or a low voice, is to diminish the size of the lettering.

```
A FEW
HOURS
LATER...
```

Caption: A sentence or sentence fragment that appears in the panel, but not in a balloon. Usually, captions are enclosed in a rectangle or box and, although they are usually at the top of the panel, they can be inserted anywhere in the shot. They are used to indicate a shift in time and/or place, as a vehicle for the author's omniscient comments or as footnotes. Recently, thought balloons have lost their popularity and writers are using, instead, captions which indicate the character's inner voice, often with the words italicized. Captions generally seem to work best when they're written in the present tense. I'm not sure why: maybe because the pictures—the other half of the comics "language"—give a sense of immediacy to the narrative that would clash with past-tense prose.

Here the writer uses captions instead of thought balloons to indicate the character's thoughts. From *Azrael* #36. Script by Dennis O'Neil. Art by Roger Robinson and James Pascoe.

GETCHER FANNY OUTTA THERE!

HE HAD A SMELLY CIGAR IN HIS MOUTH.

I GUESS HE WAS TALKING TO ME.

I HIT HIM,

AND I HIT THE MAN IN UNIFORM BEHIND HIM.

THAT WAS WHEN I BEGAN TO SUSPECT I'D DONE SOMETHING WRONG.

BECAUSE THE SECOND MAN I'D STRUCK CERTAINLY LOOKED LIKE A POLICE OFFICER.

AND THE FIRST, THE ONE WITH THE CIGAR... I SUDDENLY RECOGNIZE HIM.

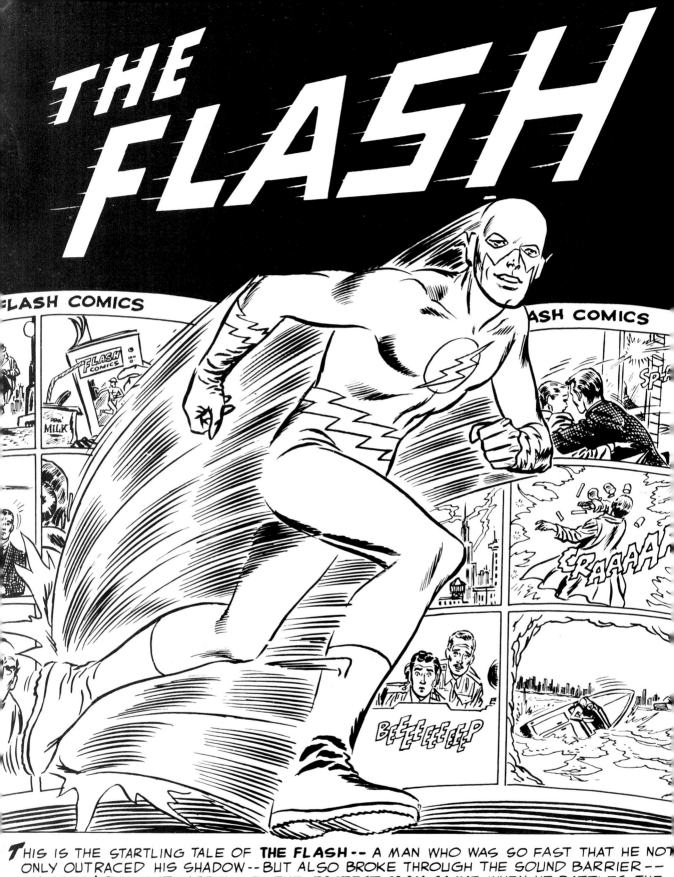

THIS IS THE STARTLING TALE OF **THE FLASH** -- A MAN WHO WAS SO FAST THAT HE NOT ONLY OUTRACED HIS SHADOW -- BUT ALSO BROKE THROUGH THE SOUND BARRIER -- ON FOOT ! BUT WHAT HAPPENS TO THE **FASTEST MAN ALIVE** WHEN HE BATTLES THE **SLOWEST MAN ON EARTH ?** IS HIS INCREDIBLE SPEED A HELP -- OR A HINDRANCE ? HOLD ON TO YOUR SEAT FOR THE AMAZING ANSWER AS YOU READ...

MYSTERY OF THE
HUMAN THUNDERBOLT

18

Story: One issue's worth of narrative that fits the story definition.

Story arc: A story that takes several issues to tell. We borrowed this term from our television brethren.

Graphic novel: A long story, usually in special format—bigger pages, hard covers, better printing. Graphic novels, if they're done well, have greater complexity and scope than one-issue stories.

Miniseries: Another video-spawned term, this refers to a title that has a predetermined number of issues. Similarly: Maxiseries.

Flashback: The dramatization of an event that occurred earlier than the main action of the story. In other words, showing something that happened in the story's "past." Flashbacks are overused and, I think, generally to be avoided. Two caveats about them: First: Go into flashbacks only when the logic of the story demands them—when a character needs to recall something that has a direct bearing on what's happening to him, for example. (The old *Kung Fu* television series made flashbacks a regular feature and used them superbly, to show the hero's early life as a Buddhist monk and, inevitably, how what he learned at the monastery bore on whatever problem he was facing.) Never, never stick a flashback into a story arbitrarily. Second: Be certain that the reader understands that you're doing a flashback. Err on the side of being ridiculously clear. Use past tense captions. Call for special coloring and scalloped panel borders. If the flashback is being narrated, you can even ask for small head shots of the narrator to appear in the captions—a corny device, maybe, but one that insures absolute clarity.

Story spine: Screenwriter William Goldman, who introduced me to this term, says it is, simply, what the story is about. Put another, slightly more complicated way, it is the sequence of events leading to the inevitable conclusion. Any event that has nothing to do with reaching that conclusion can be said to be "off the spine."

There's another device peculiar to comics that I'd like to mention here, but I don't know what to call it—it doesn't have an accepted label. This is the use of symbols-as-words, a kind of visual shorthand. Thought balloons are a pretty good example—the scalloped edges tell the reader, without explanation from the writer, that the character is not voicing the words. Some other familiar examples:

Speed lines: These indicate motion.

Radiation lines: These show that an object is hot or radioactive or that a character is experiencing emotional agitation.

From *The Flash* #162. Art above by Paul Pelletier and Doug Hazelwood.

(opposite) From *Showcase* #4. Written by Robert Kanigher and drawn by Carmine Infantino.

Light bulb: When a light bulb appears over a character's head it indicates that he or she has just had an idea—a bright idea, of course, which is why the character is almost always grinning. The inspirational light bulb was once a staple of humor comics, but it hasn't been used much, if at all, in the last couple of decades.

Multi-image: This means exactly what it says—several images of the same character within one panel to trace the path the character has taken in the shot and, often, to indicate that the character is performing several kinds of actions in a short time. Usually, only the last image in the series appears in full color; the others are rendered in lighter colors, indicating that those images show how the character appeared a second or two ago.

Typography: By varying the style, size, and density of lettering, it's possible to suggest different kinds of speech. To my mind's ear, THIS IS A SHOUT, THIS IS A WHISPER, *this is a line spoken tensely,* this **word** is spoken with emphasis, a bit louder than normal. Once, it was standard practice for editors to make several words in each balloon bold, sometimes without regard to the content of the dialogue. The idea was to provide the reader with eye candy—to vary the presumed monotony of ordinary lettering. There may have been a bit of validity in that theory but only, I think, a bit; and when illogical words were emphasized the practice may have slightly damaged the literary and narrative quality of the work.

Before we move on to actual scripting, allow me a few lines of digression which may be useful if you want to convince your more learned friends that comics are pretty darn intellectual, by golly. Tell them that comics aren't just frivolous entertainment—no sir, comics are a semiotic entity. Semiotics, according to the best primer on the subject I know of, is "simply the analysis of signs or the study of the functioning of sign systems." So we can now refine our previous definition. To wit: Comics are a narrative

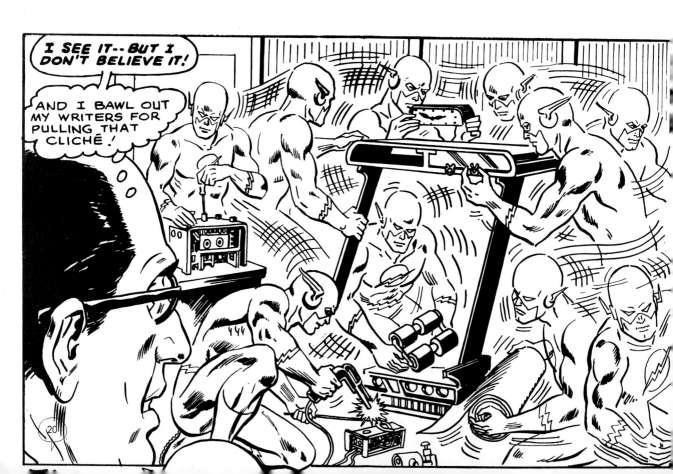

form using a system of signs and images combined with conventional written language. That'll impress 'em.

We're not quite done with definitions. (Actually, there are a lot to come, but I promise that they'll be painless.) Those of you who are new to comics should know what we call the various creative people involved in the production of a comic book. So:

Writer: Ah, you're ahead of me. The writer, of course, is what you want to be if you're reading this, the person who plots the story and produced the script which tells that story. Sometimes—quite often, in fact—the writer is also the penciller. He or she can be the inker, the letterer, or the colorist, but these cross-disciplines are relatively rare.

(opposite) Multiple images of the Scarlet Speedster from *The Flash* #179. Written by Cary Bates and illustrated by Ross Andru and Mike Esposito.

The larger type in the balloon at right is the equivalent of shouting. From *JLA* #44. Script by Mark Waid and art by Howard Porter and Drew Geraci.

16 At the last possible moment. RED manages to leap in front of the BOTTLE CITY, creating a protective ELECTROMAGNETIC FIELD from which the CHUNK bounces aside.
 OBSESSION and MAXIMA both turn to see that RED is highly steamed that the women's battle had endangered the inhabitants of the Bottle City.
 RED sends out an impressive electromagnetic DISCHARGE that brings down a HUGE SECTION of FORTRESS CEILING ...
 ... which collapses and seals OBSESSION and MAXIMA off in another part of the Fortress. far from the Bottle City.
 On the other side. OBSESSION reaches out tentatively towards the WALL of RUBBLE. taken aback by the angry Super-response ("D-Darling?"); a still fighting mad MAXIMA is headed her way.

17 Back by the Bottle City, BLUE [carrying a small box. no larger than a toaster. bearing a S.T.A.R. Labs imprint; Blue got it (pre-packaged) from a S.T.A.R. storage depot] arrives at RED's side; Red: "What took you so long?"
 BLUE looks around at the visible destruction. telling RED. "It looks like we'd better get to work before the whole place is brought down!"
 Cut back to OBSESSION and MAXIMA. again trading punches as they tumble through midair into one of the Fortress's HOLOGRAPHIC DIORAMAS (which show periods from Krypton's history).
 OBSESSION pauses in mid-punch. briefly distracted by hologram of JOR-EL, who facially resembles her "darling"; MAXIMA seems distracted. as well. as if she were hearing a distant voice. [Max is mentally reading the approach of ... well, you'll see next panel ...]
 A Kryptonian WAR-SUIT suddenly smashes into the place, knocking MAXIMA aside.

18 OBSESSION warily faces off against the looming WAR-SUIT. *they divide into 2 MORE SUPERMEN in DIFFERENT COLORS!*
 But then. BOTH SUPERMEN emerge, phasing out of the WAR-SUIT!
 And then. the TWO SUPERMEN ~~merge into each other. transforming into the classic caped SUPERMAN.~~ who reaches out with loving open arms to OBSESSION!
 OBSESSION and SUPERMAN lovingly embrace and kiss!
 And then. as OBSESSION's EYES widen, *ALL FOUR* SUPERMAN begins to crumble into dust!
 The 4 SUPERMEN keeps on crumbling as OBSESSION screams in horror!

19 Cut to the screaming OBSESSION. in the same pose from the end of last page, but now we can see MAXIMA standing behind her. Max's hands gripping the sides of Obsession's head; there's a GLOW to Max's eyes [yep, most of last page was a mental illusion which Max had fed into her mind]!
 OBSESSION's eyes glaze over as MAXIMA brain-blasts her, leaving her with the fleeting impression that she must shun Superman or else cause his death. while numbing her memory of the Fortress.
 As RED emerges from the WAR-SUIT, OBSESSION (her eyes blank and staring) streaks straight up and away, crashing through the ceiling of the fortress on her way out. [She's on her way to a future issue of SUPERBOY, to whose title character she'll eventually transfer her affections.]
 RED approaches MAXIMA, looking ceilingward, "Where'd you send her?" Max: "Away. She's of no further consequence to you."
 MAXIMA suddenly looks wary, "Where's your other half?"

The stages of creating a page from *Superman: Man of Tomorrow* #10. Plot by Roger Stern comes first. Pencils by Paul Ryan. Script by Stern. Inks by Brett Breeding.

Penciller: The first part of the art team. The person who draws the pictures in pencil. Pencillers share with writers the primary storytelling chores. The finished pencils are sent to the writer or editor for placement of the dialogue balloons.

Inker: The artist who adds India ink to the penciled pictures to make them easy to print. The inker does a lot more than go over pencil lines with a pen or brush. Inkers add texture, shading, shadows. If a panel has the illusion of depth, or convinces you that the scene is happening at night, or the figures in it are convincingly three-dimensional, thank the inker.

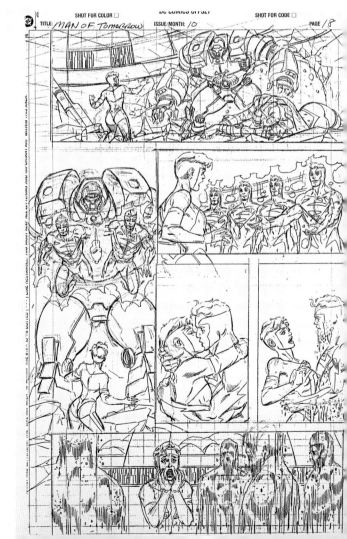

1 Dana: All right -- hold it right there!!

2 Dana: I don't know who you are in that walking tank, but --

3 Warsuit: It's okay, Dana --

4 Red: -- it's just us: Maxima won't bother us anymore.

5 Dana: Blue ... Red ...

6 Blue: Blue ...

7 Green: Green ...

8 Yellow: Yellow ...

9 Red: Red ... we all love you!

10 Dana: You ... do?

11 Red: Mmm-hmm.

12 Dana: Oh, darling, I've dreamed of ... this?

13 Red: We'll love you forever, Dana ...

14 Decayed: ... till death ...

15 Other: do

16 Third: us

17 Fourth: part

18 Dana: No! No-no-no-no!!

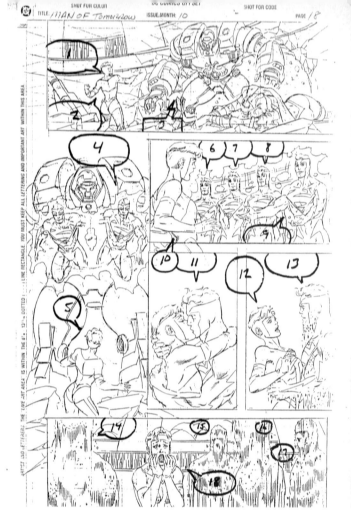

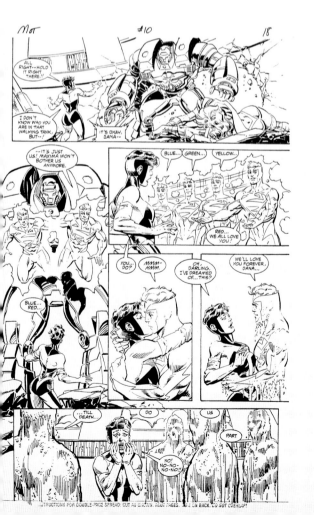

Letterer: The person who letters the copy and draws the balloons, captions, and outlines the panels in India ink.

Colorist: When penciller, inker, and letterer have done their work, the entire job is photographically reduced to comic book-page size—6 1/2 by 10 1/4 inches—and given to the last of the creative personnel, a colorist who uses a form of watercolor to bring the story to multi-hued life. In recent years, many colorists do their work on computers, which eliminates the need to reduce the page photographically—the art is simply scanned, then given to the colorist as a digital file. This ultra-modern method is easier and it gives the colorist a much larger number of options.

FULL-SCRIPT VERSUS PLOT-FIRST

The writing of comic books does not contradict the rule which states that there is seldom one absolute, inarguable, unimpeachably right way to do anything. I know of no two good writers whose scripts look the same.

So there is no right way? No. The way that works is the right way. Your pages may be vastly different from mine, but if they do the job, they're perfectly splendid.

And what job is that? Just this: telling your story as clearly as possible. I emphasize clearly because one of the recurring and embarrassingly valid criticisms of modern comic books, particularly the adventure and fantasy titles, is that they're extremely difficult to understand on the most basic level. Sometimes, it might be easier to breeze through your little sister's dog-eared copy of *Finnegan's Wake* than to understand why the guy in the purple cape is bashing the guy in the orange mask. And what is the guy in the purple cape's name? Who's behind the orange mask? Where on (or off) the Earth are they? What year is this? What century? If the writer and artists have done their jobs, the reader will be fed the answers to these questions without ever realizing it. The technical term for giving readers information necessary to understand the story is *exposition* and we'll return to it shortly. At the moment, we're concerned with the mechanics of presenting the words and pictures. Fail at these and nothing, including the niftiest exposition in the history of narrative, will have any meaning for the audience.

There are two kinds of formats (with dozens of variations) for getting your story to your artistic collaborators and, eventually, to the reader. At DC Comics, where I work, we call them "plot-first" and "full-script."

Plot-First

This method was devised in the early sixties by Marvel Comics' founder, guru, guiding light, and eternal inspiration, Stan Lee, who taught all of us who have come after him a lot, including his way of putting a story down on paper. When Stan was creating Marvel, he was writing the entire line of magazines virtually alone—about fourteen super

Doug Moench's plot for *Green Lantern: Dragon Lord* gives the artist a lot of fairly detailed information and even incorporates some dialogue. Pencils by Paul Gulacy and inks by Joe Rubenstein.

GL/Dragon Lord I -- Moench -- 3

PAGE THREE: Medium shot on the two (and maybe portions of the Dragon statues); Jong Li still puzzled; Master still inscrutable. Li: But why is it lost? Master: Because gloating is not becoming of greatness. Li again: But...how can one be both humble and great?

Full shot of Jong Li & Master passing between the facing rows of Dragon statues toward temple's rear entrance. (Aerial shot?) Master: It is the only way because it is two ways, the binding of contrast, the graceful line between yin and yang. Were you truly an excellent pupil, you would know it as the Way of the Dragon. Li: Yes, of course, Master.

Twoshot, maybe from rear; Master has still not so much as looked in Li's direction. Li: ...but I need to-- Master: Those who need forev want, and those who want forever need. Only by remaining selfless is the self satisfied, all wants and needs fulfilled.

Small closeup utterly baffled Jong Li: Fulfilled by...nothing? Master/off-panel: Just so.

Shift to (some of) the other monks, their exercise now finished, starting to fall into line and file away from the courtyard's exercise area. (No need to show it yet, but FYI: They're also heading for the statue-formed Way of the Dragon leading to temple's rear entrance.)

Li's VO: How is it, Master, that you are so wise? That you seem to know everything?

Shift back to the two; Jong Li now regarding Master skeptically -- as Master displays emotion for the first time, spreading his hands and smiling broadly in sheer delight, pleased with his own joke. Master: How should I know? Li: But-- Master again: And how should you know what I know and do not know? Li again: Ah...wh-what...?

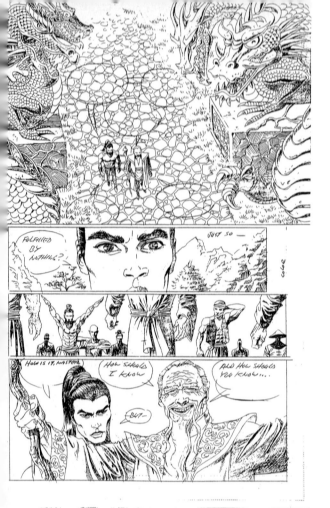

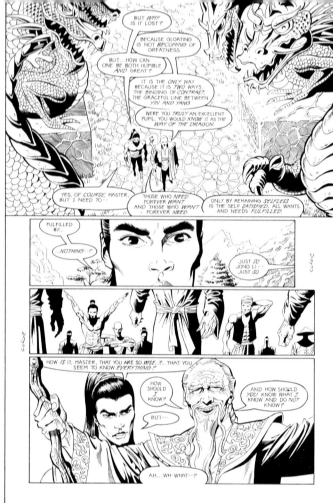

hero titles, some westerns, some humor books, and occasional odd projects that don't categorize easily. He was also editing all of the above, writing ad copy, supervising a staff, doing radio interviews, assembling letters pages, conferring with artists, and attending publishing meetings. (I don't know if he was sleeping. Maybe not.) He simply didn't have time to write full scripts.

So, instead, he gave his pencillers a plot—a few paragraphs outlining the basics of the story. The artist took this outline to his drawing board and drew the 125 or so panels that told the story visually. Those pencil drawings were returned to Stan, who then wrote the captions and dialogue and drew the balloons, captions, and sound effects onto the artwork in a blue line that doesn't photograph. The artwork was next sent to a letterer, and then to the

GL/Dragon Lord I -- Moench -- 3

PAGE THREE

JONG LI 1) But why is it lost?

MASTER 2) Because gloating is not becoming of greatness.

JONG LI 3) But...how can one be both humble and great?

MASTER 4) It is the only way because it is two ways, the binding of contrast, the graceful line between yin and yang.

MASTER 5) Were you truly an excellent pupil, you would know it as the Way of the Dragon.

JONG LI 6) Yes, of course, Master, but I need to--

MASTER 7) Those who need forever want, and those who want forever need.

MASTER 8) Only be remaining selfless is the self satisfied, all wants and needs fulfilled.

JONG LI 9) Fulfilled by...

JONG LI 10) ...nothing?

MASTER/OFF-PANEL 11) Just so, Jong Li -- just so.

JONG LI 12) How is it, Master, that you are so wise? That you seem to know everything?

MASTER 13) How should I know?

JONG LI 14) But--

MASTER 15) And how should you know what I know and do not know?

JONG LI 16) Ah...wh-what--?

inker, and, finally, to the colorist. Working like this, Stan could do several different issues of different titles virtually simultaneously and thus maintain his Herculean schedule.

In Marvel's early years, plots were pretty sketchy affairs, seldom more than a page or two of typing, and sometimes less. Stan was working with brilliant artists like Jack Kirby and Steve Ditko, superb visual storytellers with decades of experience who neither required nor wanted a lot of detail. (Eventually, I've heard, Stan dispensed with plots altogether when collaborating with Messrs. Kirby and Ditko; a brief conversation was all that either of them needed.) Today, many writers present their artists with plots that are many pages long, with every important detail literally spelled out. Often, a writer will break the plot down to pages, and even to panels; the excellent and industrious Doug Moench has been known to do plots which are longer than the final, printed comic book.

That's the "plot-first" method, and it is still preferred by many writers, for reasons that we'll discuss later.

From *Azrael* #1. Script by Dennis O'Neil and art by Joe Quesada and Jimmy Palmiotti.

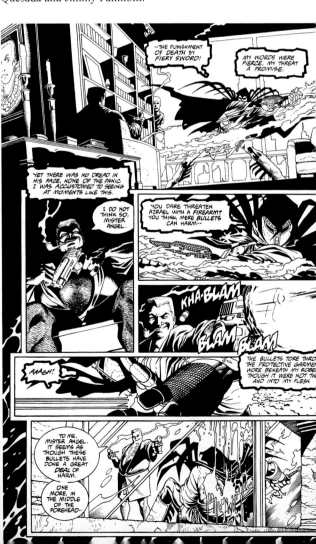

Azrael #1/

PAGE TWO

1 - OKAY, WE BASICALLY REPRISE PREVIOUS PAGE, ONLY WE'VE PULLED BACK TO GET THE ROOM IN. IT'S A RICH GUY'S PENTHOUSE LIVING ROOM WITH STATUES AND PAINTINGS AND PRICEY ELECTRONICS AND STUFF. AZ STANDS OVER Carleton LeHah, A FAT GUY WEARING A RICH GUY'S SMOKING JACKET WHO SITS IN AN OVERSTUFFED CHAIR. LIGHTING FROM THOSE BABY SPOTS THAT DEPOSIT LITTLE POOLS OF LUMINESCENCE AROUND THE PREMISES. SOMEWHERE IN SHOT, A DOOR WHICH PRESUMABLY LEADS TO ANOTHER PART OF THE PAD. OUTSIDE, OF COURSE, IT IS NIGHT. MAYBE SHOOT THIS ACROSS TOP OF PAGE.

AZ: --the punishment of death by fiery sword!

CAPTION: [ital] My words were fierce, my threat a promise.

2 - AZ POV: CARLETON. HE'S PULLING A MONSTER AUTOMATIC FROM UNDER HIS SMOKER.

CAPTION: [ital] Yet there was no dread in his face, none of the panic I was accustomed to seeing at moments like this.

CARL: I do not think so, Mister Angel.

3 - CARL'S POV: AZ.

AZ: You dare threaten Azrael with a FIREARM? You think mere BULLETS can harm--

4 - AZ POV: CARL FIRING AT HIM. OL' CARL IS COOL AS A VIRGIN'S BRITCHES.

SOUND: Kha-BLAM BLAM BLAM

5 - AZ TAKING THE SLUGS

AZ: Aagh

CAPTION: [ital] The bullets tore through the protective garment I wore beneath my robes as though it were not there. And into my flesh.

6 - AZ LEANS AGAINST THE GLASS DOOR, STILL HOLDING THE SWORD IN HIS RIGHT HAND AS LEFT HAND CLUTCHES HIS PROFUSELY BLEEDING BOSOM. COOL CARL STANDS NEAR HIM SORT OF LOOSELY AIMING GUN.

CARL: To me, Mister Angel, it seems as though these bullets have done a great deal of harm.

Full-Script

Writers who choose the full-script method produce manuscripts that resemble movie and television scripts. Although, as I mentioned above, almost every writer I know uses a different format, the basics are always the same: Each page contains descriptions of the visual content of the panels, followed by captions, labeled—big surprise here—"caption," and then by what the character is saying or, in the case of thought balloons, thinking; these are labeled with the character's name. It is essential that the writer also indicate each comic book page; this is usually done by typing that information before the first panel of the page. Note an important difference: Comic book pages contain all the visual and verbal information that will appear on a given page in the final printed magazine. Manuscript pages are the pieces of paper on which this information appears. (It's nice if these are given numbers, too, in case the manuscript gets dropped or scrambled during a ninja attack or blows out a window or gets mixed up for some other reason.)

So which is better, plot-first or full-script? Remember the rule mentioned earlier: there is seldom one absolute, inarguable, unimpeachably right way to do anything. "Right" is whatever gets the job well done.

But each method does have its strengths and weaknesses. Let's briefly examine them.

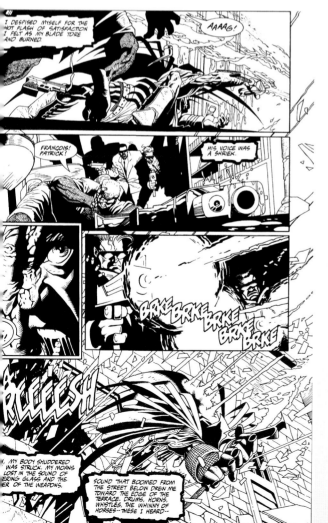

Azrael #1/

CARL: One more, in the middle of the forehead--

PAGE THREE

1 - AZ LASHES OUT WITH THE SWORD IN THE VICINITY OF CARL'S FACE--

CARL: AAAG

CAPTION: [ital] I despised myself for the hot flash of satisfaction I felt as my blade tore and burned.

2 - CARL STAGGERS AWAY FROM STILL BLEEDING/SWORD-HOLDING AZ CLUTCHING HIS-- CARL'S--FACE, WHICH IS ALSO BLEEDING. HE HAS DROPPED THE GUN. TWO MEN BEARING UZIS (OR OTHER NIFTY HIGH-TECH SUB MACHINE GUNS) ENTER FROM THE AFOREMENTIONED DOOR.

CARL: FRANCOIS! PATRICK!

CAPTION: [ital] His voice was a shriek.

3 - CU CARL CLUTCHING BLEEDING FACE, HURT AND MORE THAN A TAD MIFFED.

CARL: KILL HIM!

4 - CARL AND FRANCOIS FIRE THE UZIS--
 PATRICK

SOUND: brkebrkebrkebrkebrk

5 AND THE SLUGS SMASH THE GLASS DOORS, THROUGH WHICH AZ IS EXITING.

SOUND: t-zhing t-zhing

SOUND: KHA-REEESH

CAPTION: [ital] Again, my body shuddered as it was struck. My moans were lost in the sound of shattering glass and the stutter of the weapons.

6 - AZ AT PARAPET OF TERRACE. NIGHT, AS I BELIEVE I MENTIONED.

CAPTION: Sound that boomed from the street below drew me toward the edge of the terrace. Drums, horns, whistles, the whinny of horses--these I heard--

Advantages of Writing Full Scripts

Let's take them by the numbers:

1 The writer has full control of the story. He determines the pacing, which is something that might concern the writer more than the artist. The writer can be certain that all the plot elements are represented in the artwork. (Occasionally—just occasionally—a penciller will become so involved in making wonderful pictures, or drawing what he likes, that he'll forget about parts that may be quiet, but have to be present if the story is to make sense. When you see a story loaded with captions that explain the motives of the characters or describe events that aren't in the story, this is probably what happened.)

2 The writer can improve on his original idea. Sometimes, in the middle of writing a script, a writer thinks of a way to enhance the plot he began with. If he's working plot-first, he's stuck with something he thought of days, weeks, or even months earlier. Writing full script, he can let his new inspiration add luster to his readers' lives.

3 This one is a bit sticky, but I should mention it anyway. Writing full scripts, the writer is not relying on anyone else to get his job done. If the penciller is, for some reason, late, the writer is not forced to wait for the pages to arrive. His deadlines are his own, to meet or ignore (if he's an irresponsible no-goodnik), and not his collaborator's.

A final suggestion: Some writers—I was once among their number—sketch a suggested page layout in the margins of their manuscript to prompt artists into being aware that not all panels should be of equal size. We'll discuss why later.

Script by Chuck Dixon and art by Pete Woods and Jesse Dellperdang for *Robin* #83.

ROBIN #83 DIXON/WOODS

PAGE TEN

PANEL ONE
Robin leaps down with both feet to the foot of a chaise lounge. The lounge levers up and smacks a thug under the jaw and throws him back into another.
CAPTION: BATMAN ALWAYS SAYS TO TURN ENVIRONMENT TO **YOUR** ADVANTAGE.
THUG 1: **AGHK!**

PANEL TWO
Robin kicks a chair under the feet of the third thug who trips over it clumsily.
CAPTION: LOTS TO **WORK** WITH HERE.
THUG 2: ow!

PANEL THREE
Robin slides under that chaise as the thugs rush him with drawn daggers.
CAPTION: BUT THESE GUYS ARE **DETERMINED**.
CAPTION: WHAT KIND OF JUICE DOES DANNY **HAVE**?

PANEL FOUR
Tight shot of Robin under the chaise and looks alarmed as dagger blades come through the cushions with an explosion of stuffing.
ROBIN: aw…
CAPTION: HOW'S A **SOPHOMORE** RATE THIS KIND OF ATTENTION?

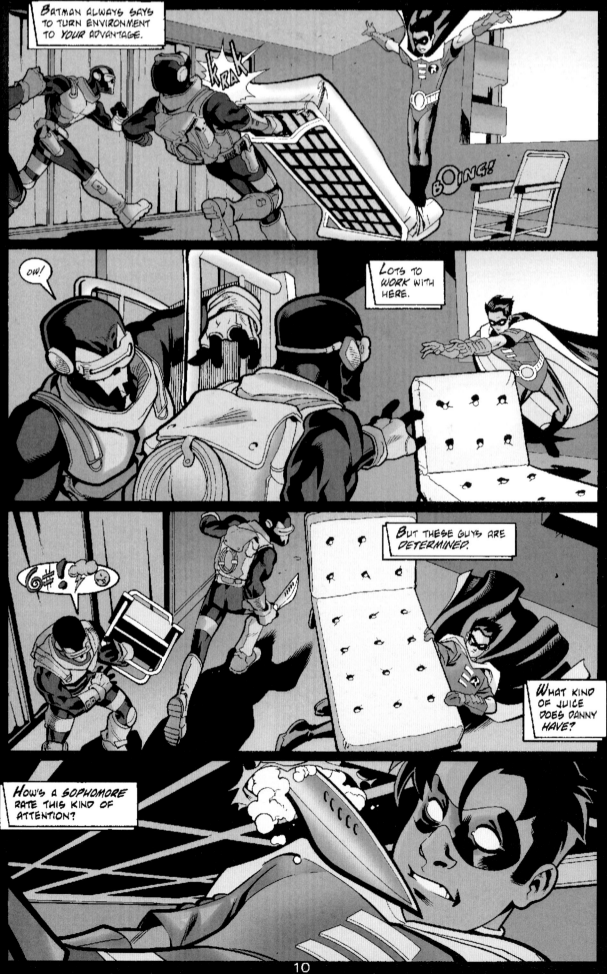

Panel 1:

Awesome, vertigo-inducing establishing shot of enormous, Brooklyn-style suspension bridge as Metallo (having seen King Kong recently) rapidly scales one of the two gargantuan concrete pillars, with Kelly in hand.

1 METALLO (animal speed and a wicked grin): *Superman! HEY SUPERMAN!!*

Panel 2:

Kelly has been hung, meat-hook style on some iron bar or outcropping at the very top of the concrete structure, while Metallo, arms raised, continues to call.

2 KELLY (Looking DOWN) [burst balloon]: *Aah!!*

3 METALLO: I'm *ready* for you, *Sucker!*

Panel 3:

Metallo middle ground, as hand reaches up and taps him on the shoulder.

4 METALLO: *Hey!* Man of *steel!* Come and meet your--
[letterer: that exploded asterisk thingey again]

5 SOUND EFFECT [small lower case] > tap-tap<

Panel 4:

Metallo whirls to see Superman standing very close, arms crossed, eyebrows raised, calm, but with the mildest trace of contempt.

6 SUPERMAN: You *rang?*

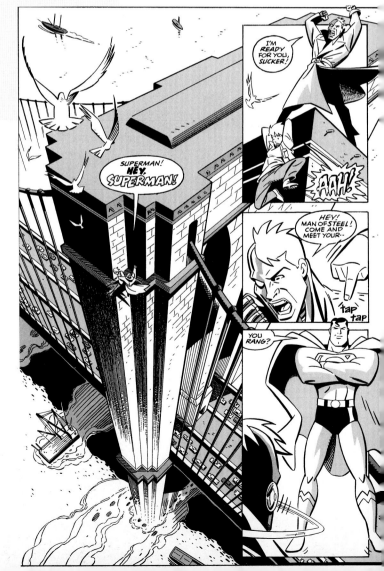

This script by Scott McCloud for *Superman Adventures* #2 gives us a good example of a writer providing the artist with a suggested layout. Art by Rick Burchett and Terry Austin.

Advantages to Plot-First

Again, by the numbers:

1 The writer can cover omissions in copy. Even working full-script, pencillers sometimes forget to put things in. If that happens when the art exists before the script, the writer can do the necessary exposition in dialogue or those talky captions I mentioned earlier. If it happens working full-script, the story is usually compromised—dumbed down a bit.

2 The writer can be inspired by something in the art. This is the reason many good writers chose to work plot-first. An expression on a character's face, a bit of body language, something in the background—any of these can suggest clever lines, characterization, even plot twists that improve the final product.

3 Lazy writers can let pencillers do their work for them. A really fine artist will handle some writing chores—pacing is the obvious one—and add interesting touches of their own while honoring the plot, allowing the writer to take credit for brilliance he might not really possess. Or, at least, quit work early.

I won't presume to suggest which method you should use. If you're working in commercial comics, you may not have a choice, especially if you're a beginner; the editor—the tyrant—will tell you what your favorite method is, and you'll agree with him if you want another assignment. And if he doesn't? You'll have to learn for yourself how you do your best stuff.

Remember: The way that works is the best way.

Before we leave this topic, I want to make you aware of a variation that combines the plot-first method with full-script method, one sometimes used by those lucky individuals who can both write and draw. I first saw it in the work of the late, tremendously talented, and much missed Archie Goodwin. During the early years of Archie's career, he would begin by sketching out an entire story on typing paper and then write his script on other pieces of paper. This allowed him to control both the visual and verbal pacing, and produce some superb comic books. If you're an artist-writer, you may want to experiment with Archie's method.

I was exposed to yet another variation when I worked in the late sixties with Sergio Aragones and Nick Cardy on a western titled *Bat Lash*. The stories were "written" by Sergio in a kind of visual shorthand. He would render the plot in his inimitable cartoon style on typing paper. Nick Cardy, working from Sergio's cartoons, then drew the job on artboard which was given to me to go the last little distance by writing dialogue and captions.

In the late 1960s, artists Sergio Aragones and Nick Cardy combined their graphic talents on *Bat Lash*.

STORY STRUCTURE

Once upon a time, in the not-too-distant past, "structure" was a word you didn't hear around comic book offices, at least not in connection with writing scripts. Nor do I remember ever hearing it mentioned in my college creative writing courses. Yet film writers consider it—pardon the pun—paramount. (William Goldman, of *Butch Cassidy and the Sundance Kid* fame, says that structure is the writer's most important contribution and sometimes his only contribution; his words will probably be changed by other writers, or the director, or the actors, but the framework on which the story is built generally survives until the movie is on a screen somewhere.)

Below, I've done a quick-and-dirty listing of the most basic kinds of structures used in comics. First, though, a couple of caveats that apply to all structures and every kind of story construction. Consider these not commandments, but suggestions: very strongly worded suggestions.

Know the end of the story before you write the beginning. You may get a better idea halfway through the work, and rethink your plot, but, unless you are very experienced indeed, or enjoy massive rewriting, you should begin by knowing what you're working toward. You should also have an idea of how many pages you'll need and communicate this information to the editor if the page-count is not part of the assignment.

When possible, start with the status quo. Show your protagonist in a "normal" state, even if he's Captain Wonderful and "normal" for him is living in a lava pit on Jupiter and being the mightiest man in the universe. Stories are, one way or another, about change, an alteration in some ordinary state of existence; it is, therefore, logical that they must show a change from something to whatever situation provides the story's conflicts. If, for reasons of space or other restrictions, you can't dramatize the status quo, at least try to suggest it.

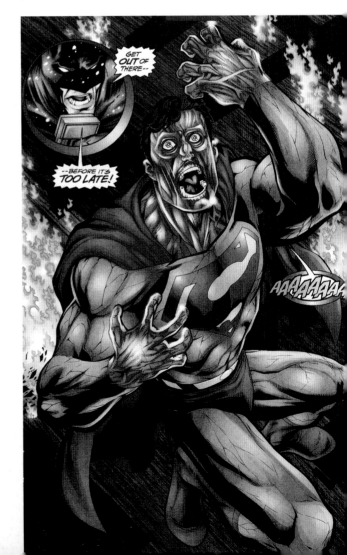

A classic cliffhanger from *JLA* #44. Script by Mark Waid and art by Howard Porter and Drew Geraci.

One-Damn-Thing-After-Another Structure

You won't find this term in any textbook or lexicon; I made it up to label the structure often found in early comics, and one that writers sometimes still use, not always to the benefit of their work. It may have been inspired by those Saturday-afternoon movie serials that a lot of future comics writers attended when they were kids. If you're younger than fifty, you've never seen a serial in a theater, but you may have seen one, or part of one, on a classic movie TV channel or rented one from a video store. What happens is, the good guy(s) and the bad guy(s) have a series of encounters, usually violent, that end indecisively until the forces of righteousness prevail and somebody who sneers a lot is either trundled off to the hoosegow or perishes. Sometimes what they're fighting over changes, but the essential conflict doesn't; two powerful antagonists bash each other and the nobler of them eventually wins.

This is not sophisticated stuff.

But it can be entertaining, at least theoretically, provided each encounter is in itself clever and the whole project moves along very briskly. But it can also be boring, possibly because it does not engage much of the reader's mind. It's a bit like watching a dancing bear: cute as hell—for five minutes. If just a single one of those encounters is not witty and/or clever, your readers will either find something else to do or will dutifully plow through your story rather than being amused by it. I guess what I'm saying is, Don't try this at home, kids.

I'd like to offer you instead a simple structure, one I've used hundreds of times, that's as foolproof as anything in the writing business ever is. I call it (please imagine a drum roll here):

O'Neil's Heavy-Duty, Industrial-Strength Structure for a Single-Issue Comic Book Story

Those of you who are familiar with screenwriting or playwriting techniques will note that what follows is simply a version of the three-act structure that is standard procedure in those forms. I evolved it years ago, before I'd ever heard of the noble three-act structure, because my early editors wanted a lot of action and usually insisted that the story be complete in a single issue. I accept no applause for this: The three-act structure is the most widely used because it is the most logical. Most stories fall into three parts whether we want them to or not. I just did what came naturally.

I'll begin by giving you the structure in outline form and then try to explain what it means.

Act I

The hook.

Inciting incident.

Establish situation and conflict.

(Major visual action.)

Act II

Develop and complicate situation.

(Major visual action.)

Act III

Events leading to:

The climax.

(Major visual action.)

Denouement.

In this splash page, Batman's shocked reaction to Alfred's sudden collapse *hooks* the audience.

"...DISTRACTING HIM WAS SO OBVIOUS A MATTER, I CANNOT BELIEVE I NEVER THOUGHT OF IT *BEFORE.*"

A c t I

The Hook

Two definitions for this. The submission guide that DC Comics used to send to writers defines the hook as "the essence of what makes your story unique and nifty." I call that *premise.* In the structure we're discussing, the hook is something on the first page—often the splash page (see definition above)—that a) gets the story moving and b) motivates the guy who's killing time in a comic shop, casually paging through a book that caught his attention, to buy it. This is analogous to the pre-credit sequence in a James Bond flick: The protagonist is involved in a venture that is exciting and interesting. But the comic book scripter's job is trickier than that of Bond's writers; they have five minutes to get the job done; comics writers have a page or, at best, two.

So how do you hook 'em? Let me quote one of the mantras often heard around the office in which I currently work: "Open on action." Pretty self-explanatory, huh? Characters doing something, preferably something big and dramatic, will probably capture a potential reader's attention. If they're doing something big and dramatic that poses a question, even better, as you'll learn in the next paragraph.

The second kind of hook: a question. A character is reacting in horror to something the reader can't see: What is it? A character is opening a box: What's inside?

Hook number three: danger. In the fifties, Joe Kubert did dozens of covers for DC's so-called war comics in which American soldiers—usually the "battle-happy Joes of Easy Company"—were about to walk into peril that they couldn't see because the enemy was lurking in a culvert or was massed around a corner or was otherwise hidden from the battle-happy Joes. That's classic danger hook stuff. A simpler, cruder version might be someone shooting at a hero, or about to shoot, or an innocent person falling out a window or from a plane, or an innocent maiden enjoying a bonbon unaware that Dracula's nasty older brother is coming in the window behind her . . .you get the idea.

Hook number four: An image so striking that the reader has to continue. Obviously, you need an extraordinary artist to achieve this; it's really more his job than yours. Will Eisner made it his signature opening and managed it brilliantly dozens of times. But, alas, few of us are Eisners . . .

If your story is such that you can't open on action, or ask a question, or put somebody in jeopardy, or smack the reader in the face with an unforgettable picture, you can either a) rethink your opening or b) at least have a character about to open a door—the reader may want to see what's on the other side.

What you never, never want to do is open on an inanimate object—a building, for example— unless it is so unusual that, in itself, it excites curiosity. People are interested in people, not things. You want to grab their attention and, not incidentally, get your story going. Still-lifes, while splendid on the walls of museums, are not the way to do that.

There's principle of dramaturgy in general, and screenwriting in particular, that's germane here: Always start a scene as late as possible. We'll elaborate on that in a bit.

(opposite) In this third page of *JLA* #43, the character's reaction to something off-panel creates a compelling question to hook the reader. Script by Mark Waid. Art by Howard Porter and Drew Geraci.

The G.I. is in big trouble . . . he doesn't know it, but the reader does. It's a good example of a "danger hook."

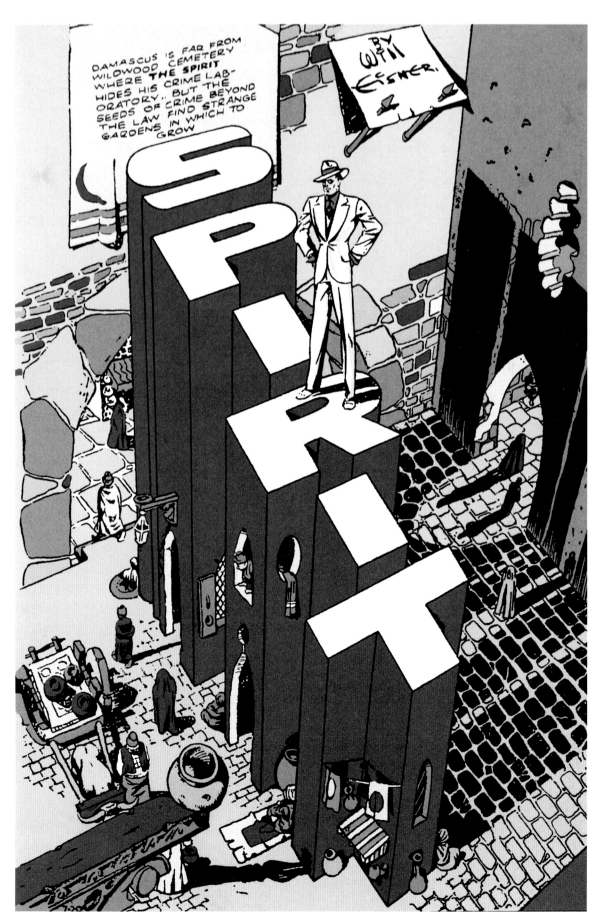

One of Will Eisner's ingenious splash pages. The art sets a mood, incorporates the logo, and is general-
ly so impressive that we want to read the story it introduces.

This is the event that causes the hero to react, that provides the danger or puzzle or task that galvanizes the hero into action. According to Robert McKee, it is what "radically upsets balance of forces in the hero's life." This is a definition that applies to a lot of Alfred Hitchcock's movies, those in which Jimmy Stewart or Hank Fonda is a more-or-less ordinary guy suddenly faced with a perilous situation. In crime fiction, it is often—surprise!—a crime, usually a murder. In the first *Terminator* flick, it was the Arnold the Android's appearance in our era. In super hero stories, it is usually, but not always, a threat to the common good—like a geeky mad scientist planning to death-ray Metropolis into cinders.

If the writer can incorporate the inciting incident into the hook, excellent. If not, it has to appear early in the story, or, if it occurred before the story opened, it must be referred to and explained as soon as possible. Think of it as the starting gun.

No wasted space here. Although Grant Morrison's *JLA* #34 script splash is quiet, it immediately pulls the reader into the story. Art by Howard Porter and John Dell.

Situation and conflict

Answer some questions for the reader: Where are we? Who's the good guy? What, or who, is he combatting? What's at stake? Until these elements are established, your story is at the starting line. (One of my former bosses insisted that the conflict had to be established no later than page two. That's a bit extreme because—all together now—there is seldom one absolute, inarguable, unimpeachably right way to do anything. But you risk boring or, worse, losing readers if you wait too long to let them in on the conflict.)

You should also introduce the McGuffin as early as possible. Since the McGuffin is always essential to the conflict, you'll do this naturally as you get your story going. So what's a McGuffin?

Jason Todd, the second of Batman's three Robins, won't live to see another birthday. This scene established the impulsiveness that eventually gets him killed. Script by Jim Starlin and art by Jim Aparo and Mike DeCarlo.

McGuffin

Time for another pesky definition: According to Alfred Hitchcock, who coined the term., a McGuffin is what the hero and villain are fighting over—the code, the hidden will, the treasure map, the computer disk which contains the information that will save the city. Said Mr. H.: "The only thing that matters is that the plans, documents, secrets must seem to be of vital importance to the characters . . . to the narrator, they're of no importance whatever."

If you think, therefore, that you should not expend much brain power devising the McGuffin, you're wrong. Although it is, to the narrator, "of no importance whatever," it must be credible. If the conflict is over something inconsequential or silly, your hero is diminished—what kind of a hero fusses about trivialities?—and that can seriously dumb down your story. (The exception to this occurs when you want to be dumb, or humorous, or both. For example, in Woody Allen's early and still-hilarious movie *What's Up, Tiger Lily?,* the good guys and bad guys vie for the world's best chicken salad recipe.) If the McGuffin is clever, as it usually was in Hitchcock's films, you've given the reader some added enjoyment.

Okay. We have our hero, our villain, our conflict/McGuffin. We know where we are geographically and historically. We are now at the end of what screenwriters would call "act one."

Act II

We should now take the story in a new direction. Something unexpected happens, maybe something that involves hero in combat with villain. If you're writing a super hero story, that something will probably involve action and a demonstration of what powers and abilities make your super hero super. If you're not doing super hero stuff, you should still try to surprise the reader by complicating your protagonist's life or introducing a new problem/obstacle for him. Get him in trouble. You want to convince the reader that he cannot possibly win. As an old short story writer's adage advises: Put your hero out on the end of a limb and start sawing.

And when you've developed the new situation(s) and complication(s) you've introduced, you're at the end of act two.

This would be a fine place to write another action scene or another plot development and preferably both.

Act III

Then, you race for the finish. Call this act three. In your remaining space, your hero solves his biggest problems, if not all his problems, vanquishes threats and evils, and restores peace and tranquility. It's nice if all that leads to a final confrontation/action scene because then you've adhered to the principle of rising action which I haven't told you about yet, but will. It's also nice—some purists would insist that it is necessary—to answer all questions: Never leave the reader wondering exactly how or why something happened.

Denouement

You're at the end of act three, and of your story. But don't type "The End" and hit the computer's off switch just yet. You might want to finish with a denouement. This is a kind of postscript, a brief scene that follows the climax and eases the reader out of your world. You may use it to answer that bothersome final question you were forced to leave unanswered in the climax, or show how your characters have been changed by their adventures, or indicate what will happen to them next. Keep it brief; it should occupy no more than a page in a 22-page story. If you find yourself writing a lengthy denouement, rethink your structure. The story's finished, dammit. Your reader may enjoy a bit of additional information, or a final visit with your characters, but if you've done your work well, there's really very little left to interest them.

Your story has done something all dramatic forms have in common: given the audience a sense of completion. This is true whether you've done a complete-in-this-issue story or written a part of a continuing saga. The characters may have further adventures ad infinitum, but for now, they're done. All questions are answered, all conflicts resolved. The end. As Tracy Ullman says, "Go home."

Now you can hit that off switch.

The above is, of necessity, oversimplified. For example, you need not introduce complications

The ring is the McGuffin in these panels from *Superman: Lex 2000* #1. Written by Greg Rucka and illustrated by Dwayne Turner and Danny Miki.

and action scenes only at the end of acts one and two. The internal logic of your story might demand they be put elsewhere, or additional complications/action scenes be inserted throughout the entire piece. If so, do it. Don't twist your plot out of shape just to conform to the outline. But often, you'll find that complications/action scenes fall naturally at act ends or beginnings.

There's another way to think about constructing a story that bears at least a few paragraphs' worth of mention, since it was favored by one of comics' greatest storytellers, Carl Barks, who wrote and illustrated hundreds of excellent Donald Duck stories for the Disney organization and, incidentally, created Donald's miserly uncle, Scrooge McDuck, surely one of the century's most memorable characters. Mr. Barks's narrative strategy, as explained to interviewer Donald Ault, reminds me of something the great crime fiction writer Dashiell Hammet said somewhere, that the best plot is the plot that allows for the most good scenes.

Here's what Mr. Barks told Mr. Ault:

". . .We always tried to get a good, interesting, climactic situation and then find a reason for that situation . . .It was a good way of making stories . . . to find a good, big climactic gag—a very interesting situation—and then build everything up to that . . ."

In other words, work backwards and let the story structure emerge organically from the incidents needed to arrive at your big finish. With this method, the writer is sure that, at least, his story is going somewhere. It does not absolve the writer from constructing a narrative that keeps moving, has rising action, concerns interesting characters who behave logically, and features some entertaining incidents before and in addition to the grand climax. Rather, it's a different process for arriving at those elements.

The danger is past, but there's still one question to be answered, and Dennis O'Neil answers it in this denouement from *Legends of the Dark Knight* #100. Art by Dave Taylor.

CREATING DRAMA

Starting Scenes

Your audience really doesn't want to see the hero park his car, get out of it, go up some steps, check his mail, open a door, walk down a hallway, hang up his coat, get a drink of water, blow his nose, yawn, sneeze, write "get nose drops" on the to-do list magneted to his refrigerator and then saunter into the parlor where waits the killer robot. They want the confrontation with Mr. Clanky; that's what the story is about. Unless any of that other stuff will be important later, omit it. The essence of drama, and especially melodrama, is compression. Show only what's important. So start the scene as late as possible and once the dramatic point is made, end it.

Rising Action

What this means is that each incident in the plot is more intense, each action bigger, each danger more menacing, each complication more difficult, than what went before. The idea is to bring the readers to an acme of suspense and emotional involvement and then provide them with a catharsis—a relief, usually pretty sudden, from the tension you've created. Keep your action rising and you won't bore readers and they'll get the emotional satisfaction a well-told tale delivers.

You won't bore the reader. That's important. If there's one great, clammy, dry-throat, sweaty-palm dread a writer should have—should cultivate—it is that, for the time needed to read even a single sentence, the reader be bored. Rising action is one insurance against this happening.

From *Detective Comics* #472. Script by Steve Englehart. Art by Marshall Rogers and Terry Austin. Cutting immediately from Dick Grayson emerging from his van to Robin quickens the pace of the story.

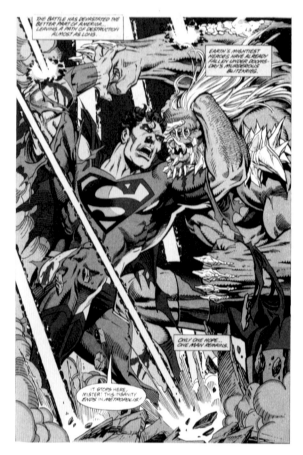

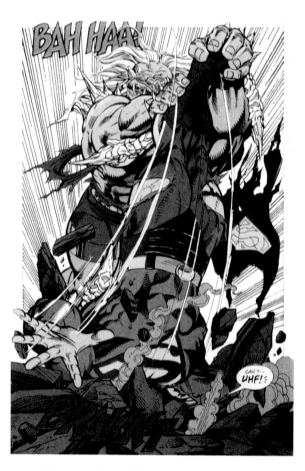

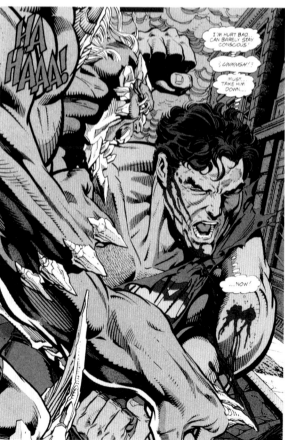

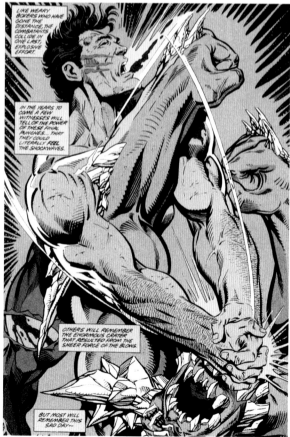

In this sequence, the action rises as Superman's fight with Doomsday takes a turn for the worse. From *Superman* #75. Script by Dan Jurgens. Art by Dan Jurgens and Brett Breeding.

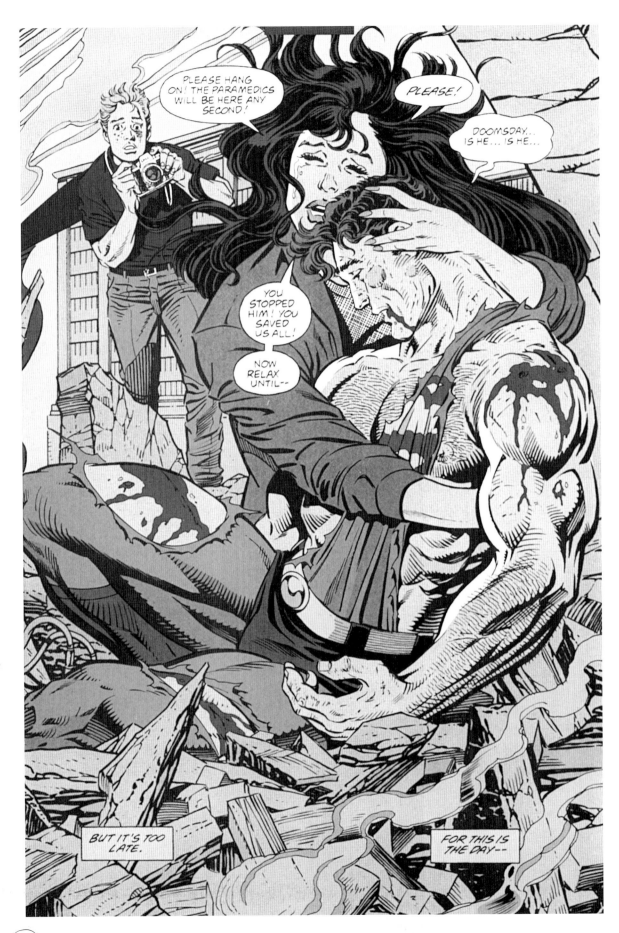

Suspense, mentioned above, is another way to insure against losing the reader. A definition would seem to be unavoidable here. I don't know exactly where I got this one from, but it served me well during the years I was teaching at Manhattan's School of Visual Arts: Suspense is the state or condition of mental uncertainty or excitement, as in awaiting decision or outcome, usually accompanied by a degree of apprehension or anxiety.

Suspense is almost the opposite of surprise. A reader in a state of suspense knows crucial facts that the character in the story doesn't and he generally knows them for quite a while. Hitchcock explained this with an imaginary situation: We're watching two people chatting, and there is a bomb beneath the table they're sitting at. Suddenly, there is an explosion. We're surprised and startled and that's pretty much that. But if we know where the bomb is, and the chatters don't, we fret, wondering if they'll leave the room or get blown to bits. As Hitchcock explained it to François Truffaut: "The public is aware that the bomb is going to explode at one o'clock and there is a clock in the decor. The public can see that it is a quarter to one. In these conditions, this same innocuous conversation becomes fascinating because the public is participating in the scene. The audience is longing to warn the characters on the screen: "You shouldn't be talking about such trivial matters. There's a bomb beneath you and it's about to explode."

Surprise has limited entertainment value. *Suspense* can keep readers enthralled. Properly executed, it builds emotion until you're ready to grant your panting audience release from it.

Working with series characters, as in comics, you can't really expect the audience to worry about whether the hero will survive that damn bomb. They know there will be another issue of the comic book. (An exception might occur if the series were ending, and everyone knew it, but don't plan on building a career from the instances when that happens.) But they don't know whether a likable but minor character will live through the deadly peril.

Another way to create a form of suspense is to cause the readers to wonder how the hero will accomplish something. Sure, Captain Wonderful will escape from the death trap—he is Captain Wonderful, after all, and his name is on the cover. But how? He's chained to a ten-ton obelisk that's sunk in a swimming pool full of man-eating guppies and he has a killer case of indigestion besides. How is the clever writer going to get him out of this one? Add another element and you just might have genuine suspense: Cap'n W. is in that swimming pool and, of course, he'll free himself before he becomes a guppy entree—but . . . his saintly grandmother is slowly sliding into a giant carrot slicer at the Giant Home Appliances Exhibition. How on earth is the Cap'n going to get out of the pool, dry himself off, change clothes, pick up the dry cleaning, and save Granny who is sliding into a carrot slicer at the GHAE which, I forgot to mention, is in Australia. Readers will be certain, in some remote part of their psyches, that Cap will succeed, but they'll be desperate to learn how. Your answer to that will constitute entertainment.

A final example of suspense: We don't doubt that the hero will best the villain, but the villain has been so darn cagey, we have no idea how that laudable end will be accomplished. One of television's great and enduring series, *Columbo,* asks the "how" question in virtually every episode produced. The structure is always the same: We see some snotty person commit a perfect murder. The louse seems to have anticipated every contingency. The crime is foolproof. There appears to be

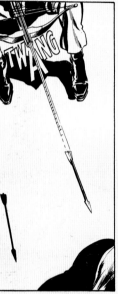
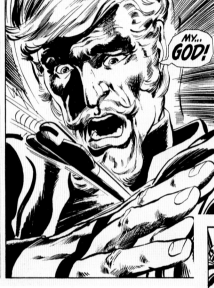

In this story, the reader is aware of something that the passersby aren't—that Green Arrow has been shot in the chest. This knowledge creates suspense. From *Green Lantern* #85. Script by Dennis O'Neil. Art by Neal Adams.

(opposite) The unveiling of Hugo Strange as Batman creates surprise, grabbing the reader's interest for the moment.

absolutely no way the shambling, rumpled Lieutenant Columbo can uncover the truth. But he does, and we sit enthralled as we watch him do it. These kinds of scripts are hard to write: The audience must be convinced that the villain has made no mistake, and the hero's solution must be both believable and clever. But if the writer succeeds, as the *Columbo* writers almost always do, the entertainment value is enormous.

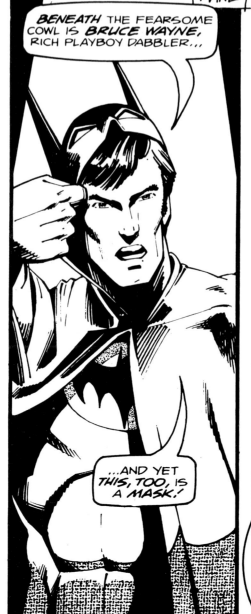

ORPHANED AS A CHILD WHEN A GUNMAN MURDERED HIS PARENTS, *BRUCE WAYNE* TRAINED HIMSELF TO WAGE RELENTLESS WAR AGAINST CRIME. MASQUERADING BY DAY AS A MILLIONAIRE-MAN-ABOUT-TOWN, HE PROWLS THE NIGHT TO PREY ON THE VERMIN OF THE UNDERWORLD AS THE DREAD...

BAT MAN

CREATED BY BOB KANE

BEFORE YOU STANDS *THE BATMAN,* DREAD STALKER OF THE *SHADOWS*...

...YET THIS IS BUT A *MASK!*

BENEATH THE FEARSOME COWL IS *BRUCE WAYNE,* RICH PLAYBOY DABBLER...

...AND YET *THIS, TOO, IS A MASK!*

FOR NOW, *PROFESSOR HUGO STRANGE* HAS *REPLACED* THEM! FROM THIS MOMENT ON--

I AM THE BATMAN!

BAT-TALE LIKE *NONE* BEFORE IT--BROUGHT TO YOU BY *STEVE ENGLEHART*·STORY; *MARSHALL ROGERS* AND *TERRY AUSTIN*·ART; *JOHN WORKMAN*·LETTERS; *MARSHALL ROGERS*·COLORS *JULIE SCHWARTZ*·EDITOR

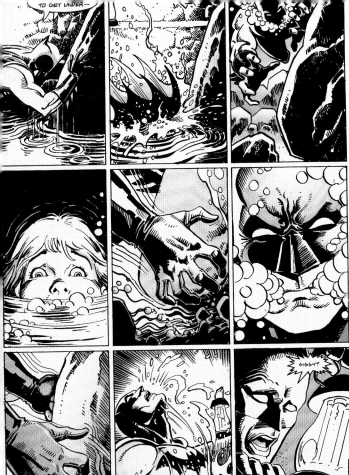

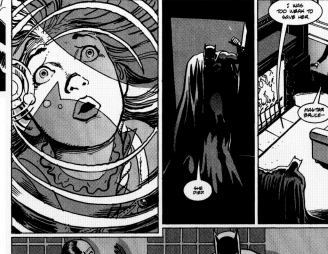

If you're prepared for the long haul—that is, if you're working on a series and you have reason to believe that you'll be working on it for a while—it's a good idea to let your hero fail occasionally. Heroic failure is the stuff of great drama, of the world's great tragedies, and is worthy of your consideration in and of itself. It allows you to plant doubt in regular readers' minds: Maybe this time, Granny will get fricasseed.

Keep the story moving

This is the last method of ensuring that readers won't be bored, and the most obvious: Never write a scene, or a single panel, that does not contribute directly to your plot. Don't look in on your characters, like a nosy neighbor. Go to them only when they're doing or saying something important. The great Russian short-story writer and playwright Anton Chekhov said that if you have a gun above the mantelpiece in Act One, be sure to shoot it before the final curtain falls. Otherwise, it will only serve to distract the audience. Edgar Allan Poe, whose poems and stories you read in high school literature texts, said that every word should contribute to the emotion you're trying to engender in the reader. We bow to the masters, who knew what they were talking about. Remember, you'd rather eat ground glass than bore the reader, and pointless scenes—or panels, or lines of dialogue—will do exactly that.

I'm willing to grant the possibility of an exception to this principle: a scene that is just so darn amusing that, although it has nothing to do with the plot, it will paralyze the reader with delight. The danger here is, what you find egregiously entertaining might leave the reader yawning. Better not to take the chance.

The outline states (parenthetically) that the end of each act should incorporate a major visual action. This applies mostly to super hero stuff. Why? Because anyone who buys a book with a cover picture of an overdeveloped mesomorph wearing a cape and mask doing something spectacular expects a certain kind of fiction. If they're anticipating a costumed demigod vanquishing a horde of vampire dinosaurs and you give them a shy schoolgirl dreading the possibility of not getting an A on her sociology test, regardless of how brilliantly you portray the poor dear's travail, they will be disappointed if they're saintly souls and seriously furious if they're like the rest of us. You've cheated them; you've stolen their money. They will not buy your work again and they may write you a really nasty letter.

(opposite) The hero fails. Bad for him, but good for entertaining readers, who shouldn't always be able to predict a story's ending. From *Legends of the Dark Knight* #16. Script by Dennis O'Neil. Art by Trevor Von Eeden, Russell Braun and José Garcia-Lopez.

SUBPLOTS

You definition-haters must indulge me yet again while I obey an irresistible urge to define the heading above. But be of good cheer—it's a short definition. Here goes:

A subplot is a subordinate plot in fiction or drama.

There. That wasn't so bad, was it?

Now, to elaborate—at length, I'm afraid.

In traditional fiction, subplots have diverse functions. Here, we'll only consider the ones most commonly used in comics. As your own work progresses, you may find yourself adding to the list. (A possible corollary to the dictum that there is seldom one absolute, unarguable, unimpeachably right way to do anything: Any catalog of narrative strategies will probably not be complete in any single lifetime.)

Meanwhile, in comics, subplots have mostly been used to show different facets of the hero's life: Spider-Man is Peter Parker when he's not slinging webs and Pete's problems are different from Spidey's; those problems appear as subplots. To a lesser extent, subplots have been used to expand the "world of the story" by showing aspects of the fictional universe not precisely germane to the main action. And they've been used to show events in the lives of minor but interesting characters, as when Superman's pal Jimmy Olsen lost his job. Here, again, subplots allow you to show more of your imaginary world and create the illusion that it exists.

Sometimes, if reader interest in a minor character is enthusiastic enough, that character is given his own series. In comics, that's happened with, among other heroes, Batman's assistant Robin, the X-Men's Wolverine, and Guy Gardner, the rogue Green Lantern. In television, it's generated dozens of shows: *Maude, Rhoda, Diagnosis: Murder, Gomer Pyle, The Jeffersons, Knott's Landing, Lou Grant, Another World, Angel*—you can probably add favorites of your own to the list. The practice of introducing potential series stars in ongoing shows is so common in TV land that there's a name for it: backdoor pilot.

No less a wordsmith that William Shakespeare was probably the first writer to employ a back door pilot, though I very much doubt he called it that. According to legend, Sir John Falstaff, originally a minor character in *Henry IV* Parts I and II, was so popular with Queen Elizabeth that Shakespeare dashed off a play which featured the jolly Sir John, titled *The Merry Wives of Windsor.*

A super hero becomes an addict. The subplot involving a drug-ridden Speedy, Green Arrow's ward, reflected and deepened the main plot in an award-winning Green Lantern-Green Arrow story. Script by Dennis O'Neil and art by Neal Adams.

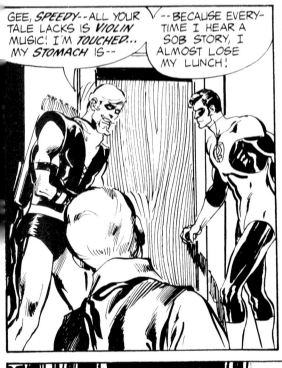

It DOESN'T END YET...IT *CAN'T!* *NEXT ISSUE*-- THE MOST SHATTERING CONCLUSION *EVER!*

The unique use of subplots in comics, unlike their employment in any other medium, has been to set up or introduce the main plot. When we get to the chapter labeled Ongoing Series, several dozen pages from now, I'll acquaint you with what I call the Levitz Paradigm, a structure in which subplots "graduate" to main-plot status.

You can write perfectly satisfactory stories that are free of subplots. But, for the reasons men-

tioned above, they can be both enriching and useful and so you should at least consider them. However, there are a few dangers you should be aware of if you decide to incorporate them into your work.

Above all else, remember this:

Subplots are plots. They must advance toward a resolution, or at least the illusion of a resolution

What they should not do is merely fill up pages. In times past, I suspect, some comics writers

The subplot in *Sandman:Season of Mists* involved an infant named Daniel with special abilities. Script by Neil Gaiman. Art by Kelley Jones and Malcolm Jones III.

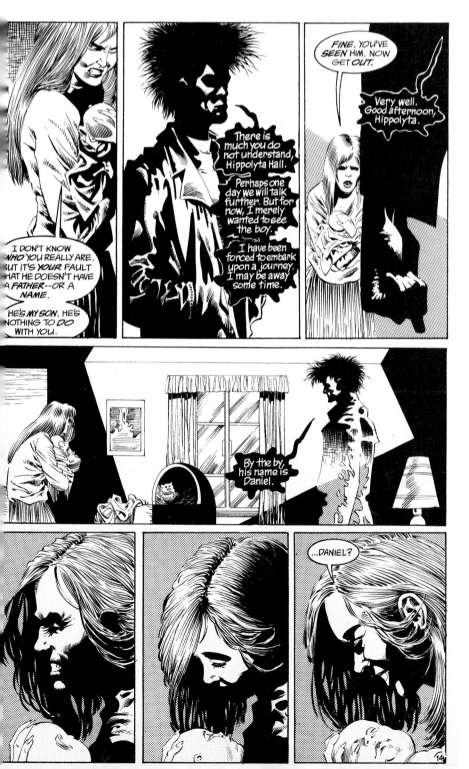

used subplots to pad issues either because they didn't have enough main plot or, in the case of multiple-issue stories, they hadn't figured out how the damn thing was going to end and their editors were demanding script or plot to send to the artist. This caused the main plot to meander over more issues than it deserved and may have given some readers the notion that nothing was really happening. Or so I suspect.

To ensure that no cynic suspects you of such malfeasance, remember what I suggested you do in the previous section: Keep the story moving. That applies to subplots as well as to the main action. Don't just look in on your characters. If they're not doing something interesting, ignore 'em. Or give them something interesting to do. (You're the writer; you're supposed to be able to do chores like that.) Never write a scene that does not advance some part of your story.

If you're writing an arc or a miniseries—we'll get to these in a while—be certain to resolve subplots by the last page, just as you resolve the main plot, lest you deny the reader the pleasing sense of closure that good fiction almost always provides. If you're doing an ongoing title, you can extend subplots a long way. In a sense, Superman's romance with Lois Lane was a subplot and that went on for about fifty years before the supercad did the right thing. But just because a subplot is open-ended is no excuse for dull scenes, which is why subplots must advance toward the illusion of a resolution. You've got to con the reader into being willing to believe that the subplot is heading toward an ending. And you should work to make the incidents in the subplot as entertaining as possible. Here, you're a little like a magician: The audience may know it's being fooled, but if the trickery is amusing, it won't mind.

You should be aware of two dangers inherent in subplotting, two sins you would be wise not to commit. The first is devoting too much space to the subplot(s), slowing the main action and distracting the reader from it. The second is the failure to reintroduce the elements of the subplot. Not every reader will have seen previous issues and those who have might be forgetful types. A rule of thumb might be: when you're writing an ongoing series, always reintroduce subplot elements if they haven't appeared for two issues. (Ideally, you'd reintroduce them every time out. Every issue is somebody's first.) Don't assume readers are as familiar with your fictional universe as you are.

We've discussed plot and structure as though they're elements separate from character and theme. They're not. They can't be. Does anyone think that's not a segue into the next chapter?

Batman looks over part of his extended family: Azrael, Robin, Catwoman and the Huntress, all of whom, except the Huntress, became stars of their own titles after appearing with the Dark Knight. Nightwing, who apparently couldn't be present for this picture, was also awarded his own book. Art by Mike Wieringo and Ray McCarthy.

CHARACTERIZATION

The famous dictum is: Character is plot, plot is character. Amen. You can't have one without the other and the reason is simple: Plot is the action of the story and the action is what the characters do. What the hero does to resolve conflicts determines the course of the tale you're telling. And who is the hero? That seems like a reasonable segue to a new section, which we will cleverly call . . .

The Hero

First, a truism:

A hero must be the agent of the story's resolution. That means that a) he must act, rather than be acted on, and b) he must be directly involved in the main plot.

He can be what modernist literati call the "anti-hero"—that is, he can behave badly—but if he is the character whose actions determine the course of the plot, he serves the narrative function of the "hero."

Most heroes also do something else: They represent values the audience will find admirable. The ancient Greeks, who gave us the basics of most of our heroic fiction, defined "hero" as one who "protects and serves." Christopher Vogler, author of *The Writer's Journey,* says that in mythological terms, the hero is "someone willing to sacrifice his own needs on behalf of others." So super heroes are powerful figures who represent a culture's notion of what is best in it and who are devoted to protecting and serving those values. For years, comic book characterization didn't go much deeper than that, and in some television versions of the super heroic it still doesn't. But comics writers have gotten sophisticated and learned that they have a much more interesting character if their superdoer does more than put on the fancy threads and dash out to smite anyone who menaces the common good.

In the eighties, some comic book writers "deconstructed" heroism by showing the good guys to be unpleasant, greedy, lascivious—traits many readers found titillating, especially when they were grafted onto heroes from earlier eras. Those stories had some immediate shock value—they certainly got the audience's attention—but, over time, deconstruction is a very limiting narrative strategy. Where do you go, once you've shown your hero to be a creep? You've given readers no one to admire, to root for, no one to identify with (unless they're the kind of readers you don't want to meet); eventually, they'll tire of someone who, in real life, they'd cross the street to avoid.

None of this means your hero should not be flawed. On the contrary, paragons of unrelieved virtue are often, alas, more admired than liked. But a character doesn't need to be perfect to not be a jerk. Part of Stan Lee's genius, when he was creating the Marvel Universe in the early sixties, lay in

Azrael, who has temporarily assumed Batman's identity, may be behaving badly, but because he drives the action, he is the story's "hero." From *Batman: Knightfall.* Script by Chuck Dixon and art by Graham Nolan and Dick Giordano.

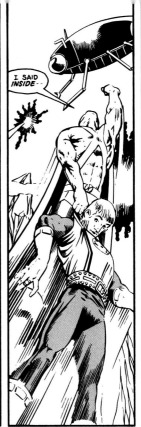

Guy Gardner misbehaves in *Justice League: A New Beginning.* Written by Keith Giffen and J. M. DeMatteis. Art by Kevin Maguire and Al Gordon.

I LATER BECAME A REPORTER, ABLE TO WALK AMONG MEN AND BE NEARBY WHEN NEEDED.

IN TIMES OF TROUBLE, I AM THERE AS. . .

SUPERMAN

TO FIGHT FOR LIBERTY AND JUSTICE, I HAVE SWORN TO PROTECT THE WORLD THAT HAS TAKEN THIS CHILD OF KRYPTON AND EMBRACED HIM AS ONE OF HER OWN.

his realizing that a cookie-cutter nobility could be pretty boring. So he invested his heroes with a lot of foibles. They were cantankerous, quarrelsome, demanding, insecure, and sometimes petty. But they got the job done, regardless of personal cost, and the job was always worth doing.

Here's the question to ask yourself when determining what negative qualities to impart to your hero: Do his flaws add to or distract from the story?

Nothing should ever distract from the story.

Superman's ideals are summed up in *Superman: Peace on Earth.* Script by Paul Dini and illustrated by Alex Ross.

(opposite) What's a super heroine afraid of? This Wonder Woman sequence from *Wonder Woman Secret Files #1* gives us the answer. Script by Joanna Sandsmark and art by Dick Giordano and Sal Buscema.

Other Characters

Either before you begin, or in the process of writing your story, you'll have to learn some things about all your fictional people, heroic and non-heroic alike. The basic question to be answered in creating character is, Why does my fictional person act this way? To answer that, it might be helpful to answer these other questions:

1 What does my person always want?
Superman wants to uphold the values he inherited from his foster parents, the saintly Mr. and Mrs. Kent, and to integrate himself into the culture of his adopted home. Batman wants to avenge his parents' murders. James Bond wants to live a life of high adventure seasoned with hedonism and, incidentally, to serve Her Majesty. Odysseus wants to go home. Sylvester wants to have Tweety Bird for dinner.

2 Who or what does he love?
His country, his family, himself, the cute blonde who sits next to him in geometry class—what? The answer to this need not be deep or complicated; Superman's "truth, justice, and the American way" is perfectly satisfactory.

3 What is he afraid of?
This is the question that screenwriter and director Robert Towne insists must be asked. In his superb screenplay for *Chinatown,* Towne's hero is Jake Gittes, a cynical private eye who seems to be fearless. But he isn't. Towne says that Gittes is afraid of looking foolish. Probably not one person in 10,000 will be conscious that this is what Gittes dreads, but if you look at *Chinatown* carefully, you'll see that it motivates much of his action. (Don't take my word for it; go rent the movie, and enjoy.)

4 Why does he involve himself in extreme situations?
If you're writing a single story, not part of a series, this question will be answered when you establish the conflict. But if you're working in a serial form, you must give your hero a logical reason to continually put himself in peril. Television folk call this the hero's "franchise." It explains why the tube is rife with cops, pri-

vate eyes, doctors, lawyers; their franchise is built into who they are. They must deal with life-and-death situations; it's their job.

Many super heroes hide their heroism behind false identities and a lot of the rest of us do, too. Many, if not most, of us show different faces at different times. (Does your grandmother know the you that your raunchiest friend does?) Robert McKee tells us that our true nature is revealed by the choices we make under pressure.

When you're writing super heroes, the mechanics of this revelation of true character are symbolic and blatant: Superman whips off Clark Kent's boring blue serge, shakes the wrinkles from his cape, and flies off to kick some Lex Luthor butt. Non-super characters show their true selves in slower, more subtle ways, generally when confronted with the pressures McKee mentioned; a lot of drama is the gradual revelation of "true character," as are a lot of human relationships.

So what about those lesser folk? If you're working in a serial form—comics, television—your good guy will have a coterie of friends and foes who recur frequently. They're almost as important as your protagonist and should be created with the same care. But every story will also have characters who, while vital to the plot development, are themselves inconsequential—the cop, the cab driver, the kid who rushes into the *Daily Planet* office to tell Clark Kent that a herd of giant robots are fricasseeing downtown Metropolis. If you just indicate "cop" or "kid," your artist will understand and do what's necessary, but you might want to spend a couple of minutes thinking of some way to individualize your breathless kid: Make him fat or skinny or tall or short or wearing a tie-dye shirt—something to impart an identity to him, however fleeting. You'll enrich your fictional world just a bit and so increase its entertainment value.

(opposite) Sometimes dialogue isn't necessary. Here, a silent Catwoman's actions reveal character. From *Batman: Gotham Knights* #8. Script by Devin Grayson and art by Roger Robinson and John Floyd.

This classic origin story appeared six months after Batman made his debut. Written by Bill Finger and drawn by Bob Kane.

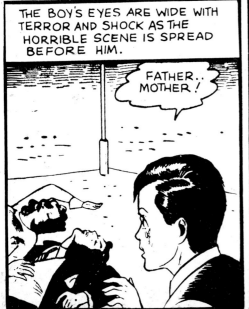

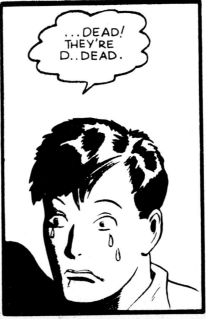

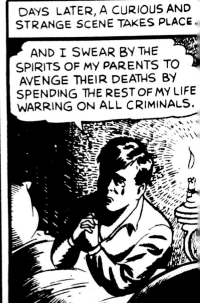

Dialogue

I've been ignoring dialogue and that's a pretty serious omission, no? The uninitiated think that dialogue is how writers reveal character. That's what writers do, isn't it? Create dialogue? Well, no. Not entirely. Character is revealed by action, not talk. In fiction as in life, words can be used to hide the truth, from the speaker as well as the spoken-to. A well-told comic book story can be understood even when written in Swahili. (I'm assuming the reader doesn't happen to be a Bantu.) But . . .

 Dialogue is important. It lends color, depth, wit, and meaning to the narrative. It explains. It clarifies. It helps create the illusion that what's on the page is a person, and not just some ink. Shakespeare told good stories, but what we remember, what makes Hamlet more than just a kid with problems is the poetry, rendered as dialogue.

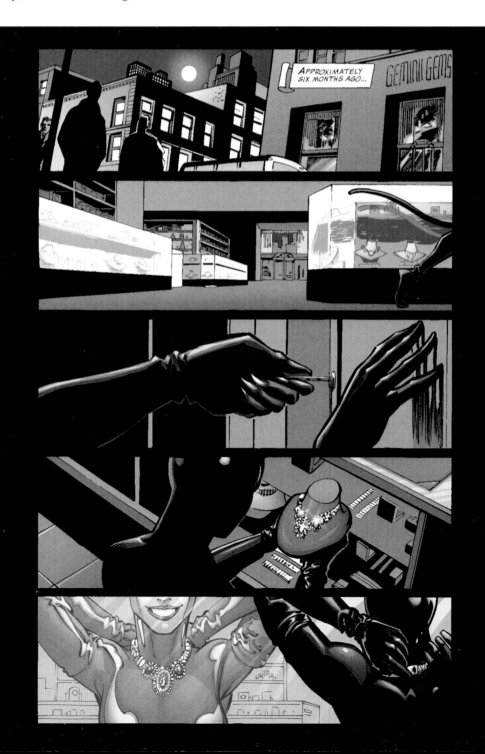

Here's the first thing I'd ask you to remember about dialogue: Use it early and often. There's been a tendency, recently, for writers to load pages with captions, often omitting speech balloons for several pages running. That's dangerous. One very good writer-editor I've worked with believes that many readers don't read captions at all, and he may be right. Even if he isn't, it's almost certainly true that captions don't have dialogue's power to engage readers. We're all interested in people and we have a tendency to want to "hear" them talk. So when writing comics (or short stories or magazine features) it's a good idea to get your people speaking as soon as possible. Tom Wolfe, a superb reporter and novelist, wrote that his peers "learned by trial and error something that has since been demonstrated in academic studies; namely, that realistic dialogue involves the reader more completely than any other single device."

William Moulton Marston used dialogue to lend color, depth, wit, and meaning to his Wonder Woman stories. Art by Harry Peter.

PAGE 12

1. CAPTION: The Queen explains the Magic Lasso to Diana.
 (The Queen is seated in her throne chair explaining. Diana stands before her holding the lasso and examining it closely as her mother points to its links.)
 Queen: It is made of tiny golden links which are unbreakable. They were taken, at Aphrodite's command, from the Magic Girdle itself!
 Diana: This chain is so fine - it is like silk!

2. (Diana is twirling the lasso as the Queen leans forward earnestly.)
 Queen: The Magic Lasso carries Aphrodite's power to make men and women submit to your will! Whomever you bind with that lasso must obey you!
 Diana: Obey me - but Mother! - what -

3. CAPTION: Doctor Althea interrupts the conference.
 (The doctor woman is entering. She stops a little distance from the Queen as the Queen holds up her hand.)
 Queen: Sorry, Doctor, I'm busy!
 Diana (thinking): I'll try this Magic Lasso on the Doc! (aloud) Wiat, Doctor! Stand on your head!
 Althea: S-stand on my head! Certainly not! Not even for you, Princess!

4. (Diana has thrown the lasso which is whirling over Althea's head. The doctor looks up at it and squeaks)
 Diana: I thought you would refuse to stand on your head. But we'll see -
 Althea: Ee-ek! Are you crazy, Diana?

PAGE 12

5. (Althea is standing on her head, the Magic Lasso is pulled tight about her skirts, holding them in place with Diana holding the lasso.)
 Diana: Now stand on your head!
 Althea: N-n- yes, Princess! I wouldn't do it but something compels me!
 Queen: Stop your silly tricks, Diana! Think of the Doctor's dignity!

6. (Althea, all injured dignity, is smoothing her hair and skirt, etc. Diana is starting for the door.)
 Althea: I came to report that Captain Trevor is better. I removed his eye bandages and -
 Queen: Bind his eyes again immediately! He must see nothing on Paradise Island!
 Diana: Nothing except me! I'll blind him again - if I can!

7. (Steve lies on his cot holding one of Diana's hands in both his own.)
 Steve: My eyes must be bad again! You're the scientist who saved my life. But you look to me like the most beautiful girl in the world!
 Diana: If you eyes are bad, I hope they stay this way!

8. (Diana is seated beside Trevor's bed. She holds a map on which he is pointing out a spot with his finger.)
 Diana: Tell me your story.
 Steve: My job in America is catching spies. I followed an important enemy agent to an island - see? There on the map. Machine guns opened up on me and I crashed - must have drifted unconscious, for days!

PAGE 13

1. CAPTION: Too soon the day arrives when Princess Diana must leave Paradise Island - perhaps forever!

So, then, my task is to teach you how to fill those word balloons with scintillating speech?

Sorry. I can't. I've never met anyone who claims to have been taught how to write dialogue. But it can't do any harm to offer a few suggestions:

1 Listen. Not only to the meaning of words, but to the cadences and rhythms of speech. Listen to the music of the human voice as well as to what it says.

2 Cultivate awareness of the difference between written and spoken language. You want to convince your readers that they're "hearing" people talk. You won't reproduce speech exactly—no fiction writer does and I suspect not many journalists do, either. In real life, and in the movies, on stage and on television, much is communicated by gradations of tone and inflection and changes of

```
little things.
                    Give me a good ending any time. You know where you are with
an ending.

PAGE 2 PANEL 1

SAME GRID, SAME PLACE, SAME SCENE. IT'S ALL VERY DOMESTIC, MARC. ALL VERY
SWEET AND REASSURING. THREE LADIES IN A LITTLE COTTAGE, HAVING A DISCUSSION
THAT COULD, QUITE POSSIBLY, BE ABOUT MAKING WOOLLY GARMENTS FOR PEOPLE. THE
MOTHER, SITTING IN HER CHAIR. SHE'S GOT ABOUT AN INCH OF KNITTING ON HER
NEEDLES NOW. BALL OF YARN IN HER LAP (AND THE END OF THAT YARN STILL GOING
OFF-PANEL). A HUGE BLACK CAT WITH GREEN EYES IS TWINING BETWEEN HER LEGS.

Mother: Now then, you mustn't say things like that. You know you don't mean
them.

        purl one, plain one, purl two together...

Mother: Why, that's what I like about making things for people. You can
start off in Birmingham and finish in, well, Tangyanika or somewhere.

PAGE 2 PANEL 2

IN THE KITCHEN. THE OLD HAG (WELL, LET'S NOT MINCE WORDS, THAT'S WHAT SHE
IS). SHE HAS AN ENORMOUS TEA POT, AND IS SPOONING TEA LEAVES INTO IT. THE
KETTLE IS STEAMING.

Mother (off):  That's not messy, my cherub. That's exciting.

Crone:  Exciting my aunt banana!

        What's so exciting about it?

Mother (off):  Well, every one we make's unique. Never seen before. Never
seen again.

PAGE 2 PANEL 3

THE CRONE, BUT IN CLOSE-UP. SHE'S POURING BOILING WATER FROM THE KETTLE
INTO THE TEA-POT. LOTS OF STEAM. WE'RE LOOKING AT THE WATER AND THE KETTLE
AND THE POT, MAINLY.

CRONE:  HMMPH. I DON'T KNOW WHY THAT'S EXCITING. IT'S NOT LIKE ANYONE
NOTICES WHAT WE DO. NOT LIKE ANYONE CARES.

Crone:  And they're always complaining: they don't like the fit of it; too
loose -- too tight -- too different -- too much like everyone else's.

PAGE 2 PANEL 4

THE CRONE. SHE'S RAISED HER ARMS HIGH, IS WIGGLING HER FINGERS AROUND,
PRETENDING TO BE SOMEONE COMPLAINING. HER RAGGEDY SKIRTS ARE FLAPPING.
SHE'S TALKING, WHITE HAIR BLOWING AROUND HER HEAD.

Crone:  It's never what they want, and if we give them what they think they
want they like it less than ever.

Crone:  "I never thought it would be like this." "Why can't it be like the
one I had before?"

        I don't know why we bother.
```

This page from *Sandman: The Kindly Ones* shows how writer Neil Gaiman handles the dialogue-image juxtaposition. Art by Marc Hempel and D'Israeli.

expression, all of which supplement the words and are sometimes necessary to the meaning communicated. These tools are not available to comics writers. Your characters have to communicate through flat words on paper, though you can imitate vocal nuances, in a limited way, by italicizing words, making them bold, diminishing them, and by varying the shape of your balloons, as discussed above. Those are handy little techniques and you shouldn't be afraid to try them. But your job is mostly to condense and heighten speech, creating the illusion of spoken language, and to do it in very limited space. Have I mentioned that comics writing is not easy?

Here's a simple trick: Read your dialogue aloud. Does it sound like spoken speech to you? If so, it's probably okay.

Observe how other writers do dialogue. You're not going to copy them, exactly. Rather, you'll try to learn what effects they achieve and how they achieve them. As the great haiku poet Basho suggested, don't imitate the masters but seek what they sought.

There is a special form of dialogue called dialect, which my favorite dictionary defines, a bit long-windedly, as "a variety of language that is distinguished from other varieties of the same language by features of phonology, grammar and vocabulary, and by its use by a group of speakers who are set off from others geographically or socially." You may call this "accent," which our dictionary defines as "the unique speech patterns, inflections, choice of words, etc. that identify a particular individual." The two meanings, for our purposes, are virtually identical. So when a feller gits to a-talkin' lak this here, he's talkin' in a accent, and the writer feller who's puttin' the words in his mouth is writin' dialect. (The feller who's talking is not a Harvard professor.)

Use dialect at your own risk.

Not that dialect is, in itself, bad. On the contrary, it has a long and honorable history, especially in American fiction. *The Adventures of Huckleberry Finn,* arguably the greatest of American novels, is written entirely in dialect. Its author, Mark Twain, né Samuel Clemens, claimed to be able to identify the dialects of different Missouri counties and, presumably, to render them accurately. But few of us have the ear or the talent, not to mention the genius, of Mr. Clemens. The danger in using dialect is twofold: First, it's hard to do and when it fails, it often fails big; and, second, historically it has contributed to racial and ethnic stereotypes. When a "Chinee fella talkee chop chop likee this, you betcha," in any work of fiction, he is demeaning an entire race; the clear implication of that dialogue is that the speaker is a jolly, childlike dimwit. And no Chinese does talk like that, so not only is the writer being racist, he's also being inaccurate. Once upon a time, maybe, writers didn't know better. You don't have that excuse.

A page from *Superman Man of Steel* #20 by Weezie Simonson written from already-existing artwork—a good example of the "Marvel style" of scripting. Art by Jon Bogdanove and Dennis Janke.

SUPERMAN: MAN OF STEEL#20 /SIMONSON/SCRIPT/22

PAGE TWENTY-TWO

1. CAP: "--answer the phone!"

2. SOUND: RING! RING!

3. LOIS: Martha, thank heaven...I was so worried. I-I'm sorry I haven't called before.

4. LOIS: I just ...couldn't. Couldn't believe it was true...that he's really dead.

5. LOIS: They...they just buried him. It...took a while to get the crowd settled down. And...

6. LOIS: ...and I asked myself what could I say to you?

7. MA: Johathan...it's Lois...that poor child. I think she needs us.

8. PHONE: *How can you forgive me?*

9. LOIS: I was there...all the time Clark fought Doomsday...

10. LOIS: ...and all I could do was report on the fight...and watch him die.

11. LOIS: I couldn't do anything...but watch him die.

12. PA: Listen to me, Lois. It's not your fault. You did all you could.

13. PA: Everyone did everything they could.

14. MA: We're coming sweetie. Hold on a little while...

15. MA: ...we'll be right there.

Am I telling you to avoid dialect, ever and always? No. If you have a gift for it—if you're *sure* you have a gift for it—then use it. If you are not so gifted, you can make effective use of what I am hereby dubbing "pseudo dialect." The technique here is to suggest a dialect without attempting to reproduce it literally. An educated individual or other person of high station will use formal grammar, Latinate vocabulary, precise diction, and employ other verbal accouterments of the privileged. Furthermore, such a personage will eschew contractions and colloquialisms. But a guy who ain't had no schoolin' is gonna drop his g's, run his words together like when he says "gonna,"an' if that ain't enough, he's gonna slang up his talk to hell an' back. If'n he's a hombre what's totin' a six gun an' wearin' a sombrero, likely he'll stick an "n" onto some'a what a city fella calls conjunctions, mebbe use a furrin word like "sombrero" now an' then an' he ain't goin' ta pay grammar no mind.

Note that both my street guy and my gunslinger contract "and" to "an'"; Context will determine how the reader "hears" the locution. Note also the misspellings—"mebbe" and "furrin"; this kind of orthographic abuse is allowable, in moderation. Finally: My street guy says "gonna" and my western-er says "goin'". That's because, in my head, I hear a difference in the mispronunciations; you may hear it differently. However, if you happen to have a street guy and a cowboy in the same scene, or even the same story, you may want to make this sort of minor alteration deliberately, to suggest different dialects for the reader.

But what about a furriner . . . pardon me—a foreigner speaking English? *Zut alors!* ze Frenchman, 'e speaks like zis? Well, he can, but, again, moderation is advised. My French national was drawing perilously close to stereotyping and, that aside, such torturous locutions can get pretty tiresome pretty quickly. (By the way, I have no idea what zut alors means. My editor will undoubtedly tell me if the translation is something like "Grandma eats worms" and insist on a rewrite.) But the sentence, he could be awkwardly phrased, with perhaps the wrong pronoun. This strangeness could be suggesting a speaker not familiar with the English.

I think it's permissible to drop the occasional foreign word into a sentence, provided it is familiar and either the meaning is clear from context or the translation is irrelevant to the dramatic point of the scene. Most people know the meaning of *si, oui, ja* and if they don't, they will be able to figure out that the character has expressed assent, *n'est-ce pas?*

I have occasionally put an entire foreign sentence into a script, ensuring that I didn't appear to be a pretentious imbecile by enlisting the aid of a wonderful, multi-lingual woman named Phyllis Hume to do the translation. I did this to give the dialogue a distinctly alien and sophisticated flavor and I was careful to surround the unfamiliar stuff with a lot of plain English for readers who, like me, did not always count staying

Early use of dialect from the brilliant and pioneering team of Jack Kirby and Joe Simon.

awake in language classes among their highest priorities in college. And I had something other kinds of writers don't have: the pictures; as always in well-wrought comics, the art helped convey information. It was an experiment, one I'm not certain succeeded. My advice is, don't try this at home, kids.

Zut alors! Know what I mean?

Humor

In an appendix to this book, you'll find a dissertation on how to write humorous stories by the man I consider to be comics' great raconteur, Mark Evanier. I wouldn't presume to second-guess Mark, so this section isn't about writing humorous comics but, rather, how to use humor in other kinds of comics. It's a subsection of the characterization chapter because, frankly, I didn't know where else to put it. Not that it shouldn't be here: Humor is a character trait when properly used, but it's also a few other things.

What's important to remember when incorporating humor into your (basically non-humorous) stories is this: It must be organic. That is, it should occur naturally and logically in the context of the action and dialogue and not be imposed from outside by a writer who's cramming it down into the scene. If you've shown that a character has a dry wit, it is perfectly appropriate to give him a wryly funny remark. If a character is established as clumsy, he can do a bit of slapstick. Sometimes, a situation can be funny, even if the story in which it appears isn't.

There are a number of reasons why you might want to incorporate some funny stuff into your serious narrative, especially if your narrative is very serious. Think back to your favorite Shakespearean tragedies and histories. Remember all the gravediggers and gatekeepers and servants and other assorted buffoons whose appearances brighten up those glum plays? You might recall the term for those scenes from high school lit classes: comic relief.

Some of you may feel certain that a definition is in the offing about now; some of you are right. According to the *Oxford Companion to the English Language,* comic relief is "an amusing scene, incident, or speech introduced into serious, tragic or suspenseful drama to provide temporary relief from tension." Enough said?

Another reason Will Shakespeare and his colleagues might have chosen to sprinkle a few chuckles into their work is that, generally, we know things by their opposites—we have a concept for light because we know dark, of low because we know high, and so forth. Maybe the tragedy seems all the more tragic because when we're witnessing it we have a recent memory of comedy.

The uses of humor just mentioned have been used in plays (and probably movies and novels) more than in comics, but comics writers might find them useful. Here's another one, more directly pertinent to comics: Humor can be used to brighten an otherwise dreary stretch of exposition. The situation is this: You're stuck with a page of talking heads in which nothing happens except that the characters talk or—perish forbid—even more than one page of talking heads, and although you've tried compressing, restructuring, and every visual trick you've ever heard of, still those characters must communicate important information by decidedly unexciting blather that seems to go on and on (rather like this sentence). Try dropping a one-liner or two into the scene. Give the folks a fillip of entertainment while they're absorbing the facts. It might help.

A couple of cautions:

• Don't have your people speak or act out of character just to get a laugh. Hamlet says several funny lines in the course of his five-act life, but they're all as dark as the rest of his dialogue. Let Will be your master here.

• If you haven't developed a knack for writing humor, don't try to use it. Ever sit in an audience while someone in the spotlight told jokes that weren't funny? Painful, wasn't it? Be kind. Spare your audience the misery.

Before we finally leave this long, long section, I'll suggest a couple of other things to keep in mind: Your characters must be "true" to themselves—that is, they must behave/act consistently. A few paragraphs back, I said that you'll have to learn about your fictional people. You might be able to do this as you're writing. For many writers, that's an option. If you're the kind of writer who needs that information before you begin, you might want to do what playwright Arthur Miller does: write, for your eyes only, a biographical sketch for your main characters. Miller puts thousands of words about his people on paper before he even starts Act One. If you're a little less industrious, or caught in a deadline crunch, you might at least want to answer the four basic questions outlined above about your main characters.

I've saved one of the most important points for last. It is so important that it deserves large, black type:

Everything that's true about creating heroes is equally true about creating villains.

If you're going to be a slacker, be lazy about your hero and save your industriousness for your villain. He or she is in some ways the most important character in your story. The reason is simple: A hero is only as good as his antagonist. That's why some kung fu movies are dull—the excellent martial arts master spends much of his screen time mowing down cardboard baddies who are obviously no match for him—and why characters like Superman can be hard to write: An ordinary bank robber is not likely to cause a guy who can flit to the ends of the universe, withstand nuclear blasts and marry Lois Lane a whole lot of worry. And if you use hundreds of words explaining why this particular bank robber is fretting the Man of Steel, you're in danger of bringing your story to a screeching halt. (Remember: you're writing melodrama and effective melodrama has to move.)

So: Your villain must be at least your hero's equal and it's often desirable if he's superior, in strength, resources, and intelligence, if not morals. Give the bad guy an edge and you give the good guy problems and the reader an underdog to root for. Provide your antagonist with motivation. Intelligent comics readers won't happily accept a nasty fellow who announces, "I'm going to unleash the herd of killer robots on downtown Metropolis because . . . I'm a supervillain!" That's really not much of a reason. And make him colorful, even if he has no extraordinary powers. (The best-known villain in comics is, arguably, Batman's arch foe, the Joker, who is physically pretty wimpy, but, with that green hair, purple suit, and white skin, he certainly is vivid.)

In *Forever People,* Jack Kirby created a villain who could match wits with even Superman in the character of Darkseid.

SUPERMAN!?

HOW ABOUT LETTING *ME* IN ON IT?

SURE, *SUPEY...* WE'RE PLANNIN' TO HEIST THE ROCKET--

--IT AIN'T CARRYIN' NO *MONEY,* BUT WE FIGURE SOME FOREIGN GOVERN-MENTS'LL PAY PLENTY FOR THE GADGET *ITSELF,* SO'S THEY CAN BUILD THEIR OWN!

I DON'T MIND TELLIN' YA... 'CAUSE YA AIN'T GONNA *LIVE* LONG ENOUGH TO DO ANYTHING ABOUT IT!

WHAT I GOT HERE IS THE STUFF AS WILL *ZAP* YA-- *PERMANENT!*

--WHAT YA CALL *KRYPTONITE!*

EITHER YOU HAVEN'T SEEN A *PAPER*-- OR YOU CAN'T *READ!*

LOOKS GOOD! MIND IF I TRY SOME?

MMMM... NOT BAD! A TRIFLE *STALE...*

...AND IT COULD USE A BIT OF *SALT...*

...BUT ALL IN ALL, A NICE LITTLE SNACK!

8

(opposite) Superman snacks on kryptonite in *Superman* #233. Script by Dennis O'Neil. Art by Curt Swan and Murphy Anderson.

In *Young Justice* #31 writer Peter David eschews balloons and captions in this amusing sequence showing Impulse trying to enlist the aid of a couch-bound Superboy. Art by Todd Nauck and Lary Stucker.

That Plastic Man . . .he sure knows the way to a goddess' heart. Witty dialogue can both deepen characterization and enliven a JLA scene. Script by Grant Morrison and art by Howard Porter and John Dell.

A few final thoughts on characterization, and then we'll leave the subject:

Early comics writers didn't worry about characterization. That's partially because the form hadn't yet evolved enough to allow for it and partially because the audiences didn't demand it: Characterization in other popular entertainments—radio shows, pulp magazines, Saturday matinee movies—also tended to be rudimentary. The writer could let the reader know that the chap with the killer robots was a "mad scientist" and he'd done all the character work anyone expected. That's no longer true. The best modern comics writers often operate, as do serious novelists and playwrights, by starting with the characters and letting the story grow from who they are. This doesn't mean that a writer can't start with an idea for a nifty gimmick or a unique McGuffin, shape the characters to fit it, and produce a good comic book. But it does mean that we writers can no longer ignore the task of creating believable, or at least interesting, people.

SCRIPT PREPARATION

Here's what you've already done: You've sat alone in a room. Or you've taken a walk. Or, like writer Devin Grayson, you've listened to appropriate music. One way or another, you've thought about your story. Maybe you've also talked it over with your significant other, a writer friend, an editor, or anyone else who's willing to listen and offer honest comments. You have a clear idea of who your principal characters are, how they'll come into conflict with each other, what they want, and you have at least a clue of how your story will end.

Now, you're ready to begin the physical act of writing.

How? That depends on who you are. Experienced writers can just begin writing, trusting their hard-earned proficiency to provide them with the particulars of their narrative as they go along. Beginners can do that, too, but if they do, they should be ready to do considerable rewriting. It's likely that some rewriting will be necessary regardless of how you prepare, or how many scripts you've done, but a little advance work now can save time and toil later on.

Many of us start with an outline. Try this: Get a sheet of lined paper, the kind you used for penmanship exercises in fourth grade, and scribble on it the main events of your story—what our television brethren call the story's "beats." Read it over to see if anything seems to be missing, or if anything doesn't stick to the story's spine. Try to estimate how many pages and/or panels each event will need. Add. Subtract. Make notes in the margins. You may discover, when you're actually doing the script, that you've guessed wrong—a bit of action that you thought would occupy a page is accomplished in a panel, and two lines of exposition have somehow become eighteen. That's all okay. Your outline is no more than a crude road map; its only purpose is to keep you pointed in the right direction.

That's one way.

Another is to write your beats on 3 by 5-inch cards or Post-its. Spread them out. Move them around. Use them as aids in shaping the plot. Continue to play with them until you think you've arranged them to form the best possible story structure.

Technophiles may want to accomplish the same thing with a computer. Every decent word processing program has a cut/copy/paste function that can move your beats from one part of your outline to another. (I know a television writer who uses his outline as the foundation for his finished script; he puts it on his screen and adds dialogue and camera directions. There's no reason why this wouldn't work for comic book scripts, provided the writer is friendly with his computer.)

Scott Peterson has a more elaborate procedure that combines elements of everything mentioned above. It seems to me that Scott's methodology is both thorough and efficient. You might want to try it. As he explained in a recent e-mail:

Before I write a story I start a folder on my computer with the name of the issue I'm going to write. Into this folder are going to go four different documents. First I write the story out in prose, which usually takes one and a half to three pages (I use the Times font, 14-point, space-and-a-half spacing, just so you know). This is the document called "Plot."

Then I have a document that simply lists from page one to page twenty-two and I fill in what happens on each page with between one and a dozen words:

> *Page Three*
> *More fight*
> *Page Thirteen*
> *Batman checks out alibi, realizes truth*

This is the document called "Outline." All along I have another document called "Thoughts" or "Ideas" or "Notes" where I jot down my, oddly enough, thoughts or ideas or notes—stuff I want to remember to put in the story to add to the subplot or subtext or just a cool visual move for later in the issue when Batman has the fight scene in the bakery or whatever—this frequently ends up being the longest document and has sometimes proven invaluable, especially when I have to stop work on a project in the middle for some reason and come back a week or two later.

And then I start writing the actual script. I've found that if I go through all these steps, the process, from beginning to end (including all those steps, plus the actual writing of the script), is not very long, but if I try to skip one of the steps, I usually actually lose time.

GOTHAM ADVENTURES #32 STORY

It's the week after Halloween and all's back to normal...seemingly. But this is Gotham, and normal doesn't exist. Seems the Scarecrow has revealed that he has spiked something Halloween related that almost everyone in Gotham has had access to and which will affect almost everyone in Gotham alike--man, woman, child...and Bat.

Naturally, the city goes insane as people begin falling under its effect.

We open on a bunch of citizens attacking our heroes in downtown Gotham. As we pull back we find they have no idea why they're doing this; our heroes were simply responding to what they thought was a "normal" heart attack or some such when they crowd started going nuts.

Our heroes do what they can to help whom they can but have to pull back and regroup. When they take their victim to the hospital--which is a complete and utter madhouse beyond imagining--they find out what's behind all this: the Scarecrow has announced that he's released his latest idea upon them all and Happy day after Halloween Gotham.

Naturally, our heroes get to work investigating what could possibly have inspired this latest outbreak. They run through the possibilities: water, air, something else? No, Scarecrow indicated it was related to the holiday. All right, then, candy? No, too many different kinds. Some particularly popular costume? Even the most popular probably doesn't have a wide enough appeal. How about those bags you get at O'Shaunessey's that kids use to trick-or-treat? Hmmm...possibly.

So they go to the restaurant to check it out and maybe we get another good action scene there. But it seems to be a deadend.

Meanwhile perhaps we see Nightwing and Batgirl doing their best to keep the city under control? And all the while, time's a ticking away...

Meanwhile, Batman's also trying to track down Scarecrow. And how in fact does he find him?

Batman realizes that the Scarecrow has to be able to observe his work, otherwise it's all for naught. So he simply goes to the highest building in Gotham, where Richard R. Rich lives. As Batman makes his way upstairs he finds the doorman, then the elevator man and then Rich's bodyguards shivering with fear--real fear this time, from an easily detectable chemical, unlike the others going crazy in Gotham.

Once Batman does find Scarecrow he gives him a taste of his own medicine by turning the lights out and as Scarecrow's in the dark he circles around him, taking out all the Scarecrow's goons one at a time until the Scarecrow knows that he's the only one left...and Batman's coming for him. And he waits. And he waits.

And he waits until the Scarecrow loses it and admits that it was all a fake and a fraud and it was just his latest idea. And the whole time, Batman's been broadcasting it to every television and radio in the city.

GOTHAM ADVENTURES #32 THOUGHTS

Is this a critique of the way we believe whatever we see on television? Ah...that's it--Batman actually figures it out ahead of time but no one will believe him in person? Does this show how susceptible people are to doing the wrong thing just because they saw it on television?

What do Nightwing and Batgirl do with the citizens? Devise makeshift pens to contain them? How? Simply chain them to fences? Use knockout gas? Start using placebos? Is that what gives Batman the idea? "When will this wear off?" "Any second now." "Hey...hey, you're right, it did!" "Wha?"

Make sure we fill the readers in on the Scarecrow enough.

Make sure the time frame is clear.

Batgirl hasn't been used much recently--have her be Batman's main foil?

PAGE ONE

Open on Batman leaning over an unconscious man or woman, feeling for a pulse while Robin looks off panel in shock.

PAGES TWO AND THREE

Pull back to see an enormous throng of people flooding the streets of Gotham towards them-- complete and utter mayhem.

PAGE FOUR

More mayhem as they try to fight off the citizens without hurting them.

PAGE FIVE

They grab the victim and take hir to the hospital.

PAGE SIX

Get to the hospital and realize it too is a madhouse.

PAGE SEVEN

Find out why...the Scarecrow!

PAGE EIGHT

We're in Gordon's office as he replays the tape the Scarecrow made. Apparently, every station in the city is playing it nonstop, along with "experts" who say nothing in a very impressive and endless way.

PAGE NINE

Discussion moves to the Batcave as they go over what it could be. As they do, we see scenes of mayhem in Gotham. Keep up the urgency.

Okay, your preparation is complete. The moment of truth has come at last. You have to write the damn script. Anyone who's been through high school probably knows what to do next; we've all had papers to write and we have learned how we best get them done. You don't need me to tell you how to proceed; you've been through this before, dozens of times. If you're Doug Moench, you'll begin writing in longhand with a stack of Post-its by your elbow and as you work, you'll scribble ideas and dialogue on the Post-its, stick them onto the appropriate notepad pages and incorporate them into the finished script or plot when you type it; the procedure is similar to Scott Peterson's. If you're Sam Hamm, you'll play games for a few minutes to accustom yourself to using the computer. If you're Chuck Dixon, you'll simply begin typing.

Scott Peterson's stages of creating a story for *Batman: Gotham Adventures* #32. Art by Tim Levins and Terry Beatty.

PAGE EIGHT
PANEL ONE
Extreme closeup on the Scarecrow his own very bad self.
 SCARECROW: Yesterday, as you know, was perhaps the year's most sacred day--Halloween.

PANEL TWO
Pull back a bit so we can see him from the chest up or so.
 SCARECROW: In order to truly enjoy it properly, I took the liberty of dosing the majority of Gotham's population with my latest potion.
 SCARECROW: Virtually every man, woman and child will soon be affected by a fear the likes of which they've never known.

PANEL THREE
And we pull back further to see that we're in Gordon's office watching the video on television.
 SCARECROW: In fact, it should begin to take effect...right...about...
 SCARECROW: ...*Now*.
 GORDON: And that's it.
 GORDON: The tape was delivered to every television channel in the city.

PANEL FOUR
Exterior establishing shot of Gordon's office in the GCPDHQ. What about maybe pulling further back and up for this than usual so we can see more of the ground level area where, once again, people are going nuts.
 GORDON: Naturally, each one rushed to be the first to put it on the air.
 GORDON: They've all been broadcasting it over and over ever since.

PANEL A: And suddenly a lightning bolt, literally right between the eyes, strikes the Carnivore's face. The impact of it startles him, causing him to lose his grip on Andy, who in turn starts shifting form.

Sfx: SHWAAAKAAAAM

ANDY 1: Blithe!!

BLITHE 2: Hey, sweetie! Miss me?

ANDY 3: More than you know.

PANEL B: Infuriated, the Carnivore swings his sword, but both the (now transformed) Comet and Blithe, in lightning form, sweep around it.

CARN 4: Gnats! Insolent gnats! Now--!

PANEL C: And suddenly Supergirl, wings and eyes afire, blasts out of the rubble, knocking demons back.

SUPER 8: Now?

SUPER 9: Now we end this, Carl! For good or ill...we end this!

PANELS D, E, and F: Over three quick panels, in a sort of triptych, we have a close shot of Blithe's left hand gripping Comet's right hand, and Comet's left hand reaching out to grip Supergirl's right hand.

CAPTION 10: Blithe, angel of light, who was lost in darkness, but will now bring illumination to he who is the most lost of all...

CAPTION 11: Comet, angel of love, who unites, creating thaw from emotions that are frozen...

CAPTION 12: And I...Supergirl...

You'll do it your way because—and I want you to put some real feeling into it this time—there is seldom one absolute, unarguable, unimpeachably right way to do anything. There's what works, and what doesn't, and ten years from now, what works may have changed.

Now some time has passed: days, weeks, hours, however long it's taken. You've labored long and mightily and the script is done—that is, the first draft is done. It's a good idea to reread your masterpiece, preferably after being away from it for a time. You might consider letting someone else read it, too: a sibling, a friend, a significant other—someone who wants you to succeed but doesn't feel you walk on water. You're seeking honest criticism, not praise. You may find that you've neglected to inform the reader how a character got from here to there, how your intrepid hero knew the killer robot was hiding in the arboretum, exactly who put the overalls in Mrs. Murphy's chowder, whatever. One of the most frequent beginner's mistakes is, in the words of my college creative writing teacher, "leaving it in the typewriter." You know what happened. To you, it's perfectly obvious. But the reader can't know, not unless you tell him. He's not reading fiction because he wants to play guessing games. So you reread to discover your omissions. And to catch spelling errors and to improve your sentences and even to make sure you've done the correct number of pages; more than once, I've had an editor inform me that my 22-page script was actually 23 pages long, or 21, because somewhere in the writing I'd misnumbered.

Then you rewrite to correct your errors.

You may not be finished yet because now it's the editor's turn. That godlike personage may see mistakes you've missed—hey, nobody's perfect—or he may think the script needs more action, or less action. Or you may have violated a rule of his that you weren't aware of. Or the legal department may feel that the drooling cretin whose own stupidity gets him eaten by the killer robot too closely resembles a talk-show host who loves to sue publishers. Don't be upset when asked to amend your script. A worthy editor has one primary directive: to make the creative people look good. To do this, he must

sometimes demand further work. He doesn't do it casually. Remember, more work for you means more work for him, too.

If you believe you've mastered everything in this section—if you know, as you know how to take your next breath, all the intricacies of story structure, characterization, suspense, pacing, dialogue, and your script preparation causes editors to swoon with joy—you're either a) deluded or b) kidding yourself or c) in no need of help from me or any other writing instructor and why are you bothering to read this book, anyway? But you probably don't. However, you might now have some idea of the basics of comics writing, a bare beginning you can spend the next couple—three decades developing and evolving remembering as you do so that, yes, there is seldom one absolute, unarguable, unimpeachably right way to do anything. This you will do not by rereading my words, or taking classes, or talking with your friends, but by sitting down for a given number of hours each month and doing it. Writers learn to write by writing.

Everything I've discussed to this point has been about writing a single, complete-in-one-issue story. You'll have to know how to do that before you can attempt longer, more complicated projects. But eventually, you'll probably want to try doing graphic novels and limited series and if you get assigned to an ongoing title, you'll have to deal with problems of continuity. Those are the topics you'll begin reading about as soon as you turn the page.

Supergirl shows her stuff, as every good superbeing should at some point in every story. Script by Peter David. Art by Leonard Kirk and Robin Riggs.

PART

TWO

True story, with details changed to protect the innocent—or, more precisely, the naive:

Guy wangles an appointment with the editor of a major comic book company. Although he's never published a comic book story, or anything else, he wants to write comics. He has some good ideas about one of the company's characters. (For purposes of this slightly fictionalized account, let's say that the character is our old friend, Captain Wonderful.) Impressed with the guy's enthusiasm and, maybe, remembering his own early career, the editor asks the guy to develop those ideas and come back later.

A week passes. Guy comes into the editor's office with four years' worth of Captain Wonderful continuity in outline form. The editor thanks him for dropping by and wishes him a nice life.

Moral? Well, for openers, the guy was, to put it gently, ingenuous, to think that any publisher would entrust 48 months' worth of a major property to a completely untried talent. Few established writers are given that kind of license. No editor wants to commit to four years of anything—there are too many circumstances likely to change over such a span of time. And if I were that editor, I'd have to doubt the neophyte's ability to sustain a narrative of over a thousand pages without there being a lot of dead spots. Remember what we discussed in the previous section: The story must continually move. The action must rise. There should be no scene that doesn't advance the plot.

A beginner is going to manage all that for a thousand pages? Not any beginner I've ever met, and I've worked with beginners who were eventually numbered among the best writers in the business. What our beginner probably should have done was to present the editorial director with an outline for a ten- or twenty- page story, listened eagerly to any comments offered and been willing to write a script on speculation or "spec"—that is, with no guarantee of publication or payment. Your first script—your first dozen scripts—are going to be primarily learning experiences. If they get into print, fine. But whether they do or not, they'll be valuable because, as you may have heard somewhere, writers learn to write by writing.

But let us not judge our guy harshly. His mistake was understandable. Anyone born after . . . oh, say, 1939, has mostly experienced fiction in serial form. We've all read novels and short stories about characters who we never expect to encounter again, but for at least the last half-century or so, we've gotten our fiction primarily through television and, I'm assuming, comics, and those forms deal chiefly with continuing characters, often with continuing storylines. (Nor is serialized fiction confined to the tube. More and more, novels and movies are created with the hope that they evolve into franchises, which is mediaspeak for a lot of stories about the same people.)

You may not have missed a single episode of *Magnum PI* and still not be able to recall even one plot, but you remember Thomas Magnum, Higgins, the Ferrari, Rick, TJ, the estate, the dogs, the long-suffering lawyer. . . . The plot was usually concluded in fifty or a hundred minutes, but the rest of it oozed into your living room for years. So of course that's what you remember. But I'm convinced that if those forgotten plots didn't engage you at the time, if good old Tom Magnum's adventures were snoozers, you wouldn't have returned to the show week after week. Plots, and rising action and the rest, will always be important.

Which brings us, rather long-windedly, to comics' long forms. They are: the limited series; the mini-series; the graphic novel; and ongoing titles.

MINISERIES

The definition: *A miniseries is a title that has a predetermined number of issues.*

Before you begin writing a miniseries, you know you have a given number of pages to fill. These are divided into issues, usually between three and six, though some are as few as two and some as many as six. The format varies: They can be printed as regular comic books, with the same paper and production techniques as any ongoing title or they can be given a grander treatment—slick paper, thick covers, lavish, full—color printing, much like the fancy art books that are given as Christmas presents or left casually lying around on coffee tables to impress Aunt Minnie.

I'm going to give you two rules for writing them, or what I'll call rules, though you should bear in mind that . . . sigh . . . there is seldom any one absolute, unarguable, unimpeachably right way to do anything.

RULE 1: Have enough story to fill the allotted number of pages.
You don't want to get halfway through issue three of a four-issue series and find you've run out of story and you don't want to be guilty of writing a single panel—a single line—that does nudge the story toward its conclusion. That's called "padding" and consummate craftsmen like you don't do it. So if you do have more pages than story, you may have to rethink your entire plot and do massive rewrite or, worst case scenario, start again from the beginning. Novelists, short-story writers, poets, and screenwriters sometimes do exactly that, with good results. There's only

one reason why it might not be a good idea for comics writers; most commercial comics writing is done to a stringent deadline. If your project isn't deadline-intensive, and you're the kind of writer who likes to experiment with various narrative techniques, or climb inside your fictional world and wander around for a bit, or try different endings like your fussy cousin tries on jeans at the Gap, then by all means sit down, start typing, and see where you go.

However, if you are working on deadline, use one of the methods explained in Part One to shape your story before you write it. Unless you're an experienced professional, you may still have to put in rewrite time before you deliver your manuscript; as with single-issue stories, you'll find that your outline doesn't always accurately gauge how much space each scene will demand, and that some outlined scenes will have to be abandoned while others stretch far beyond the number of pages allotted for them. But pre-writing preparation insures that you won't spend days, or weeks, reworking your material.

RULE 2: There must be a major change, development, or reverse in every issue. This is just another version of the "keep-the-story-moving" dictum. Something important must happen in every issue of the series. Each must have at least one turning point or surprise. And in each, the hero must either accomplish or learn something.

A four-issue series might break down like this:
Issue 1: Introduce the hero and establish status quo. Hero learns of/defines problem. Encounters first opposition.
Issue 2: Hero finds allies and/or means of combatting villain. Opposition intensifies.
Issue 3: Hero seeks solution. Opposition intensifies.
Issue 4: Hero finds solution and solves problem.

The four-issue *Robin: Year One* series was written by Chuck Dixon and Scott Beatty. It was illustrated by Javier Pulido, Marcos Martin, and Robert Campanella.

Three additional considerations:

• Each issue should end on a reason for the reader to continue buying the series. This can be something as crude as an old-fashioned cliff-hanger—Captain Wonderful is chained to that darn obelisk at the bottom of the pool full of carnivorous fish and the reader will have to get the next issue to find out how he escapes. Or it might be a bit more subtle—Cap has discovered that his staunchest ally seems to be sabotaging him and the reader yearns to know whether this can possibly be true. In either case, you've posed a question that you hope the reader will want answered.

Some of your audience will make a commitment to the entire series before they pick up the first issue, especially if they like the hero or any of the creative team, but many won't. They'll sample, and let their reaction to what they see determine whether they'll follow the story through to the end. Sales figures confirm this: There's always a decrease in sales between issues of any series, sometimes slight and sometimes precipitous regardless of how good or bad the material is. Obviously, it's in everyone's best interest if the difference between the first and last issues' sales is 10 instead of 90 percent.

• The beginning of each issue after the first should incorporate a brief summary of what's gone before. Your reader may be sampling the second or third issue and if he can't fathom what's happening, he'll abandon the series. But if he does get interested, he may buy the next issue or even ask his dealer for the earlier stuff he missed. So feed him enough information to let him understand what the conflicts are, what's at stake, where the action is taking place. The simplest way to do this is to plunk down a block of copy on page one. Ever read the Prince Valiant newspaper strip? The first panel always features a picture and, beneath it, a caption labeled "Our Story": In a couple of dozen words, the writer tells us where Val is and why he's consternated. It's a clumsy technique, but it gets the job done. You might consider doing your own version of Val's synopsis; it won't enhance your reputation for cleverness, but it's better than risking a puzzled reader.

There are other options, but they require effort. The slickest method is to slip exposition into dialogue or panel captions spaced throughout the first couple of pages, but don't start your exposition too far into the episode lest you lose the reader's attention. You can also resort to a flashback which incorporates all you want the reader to know. This is tricky: A flashback placed too early in the issue delays the start of the action and slows the narrative to a crawl; but a flashback that appears a third of the way through the issue, or later, may not accomplish the task of imparting information the reader needs.

Using a flashback to recap what's already happened is a good technique, but one that should be used sparingly and only when necessary. Note the heavy borders and rounded corners. It's the artist's way of signaling that what we're seeing isn't in the present. From *Detective Comics* #471. Written by Steve Englehart. Art by Marshall Rogers and Terry Austin.

• We'll return to this final point when we discuss ongoing titles, but it's equally pertinent to miniseries and so worth a mention here: If a character hasn't appeared for a while, for fifty pages or more, reintroduce him, especially if he's a minor character who's important to the plot. Let the reader know who he is and why he's in the story. Be kind: The reader may be having a bad day and not remember every detail of your brilliant narrative.

Wonder Woman: Second Genesis ends with a cliff-hanger, compelling readers to continue reading the series. Written and illustrated by John Byrne.

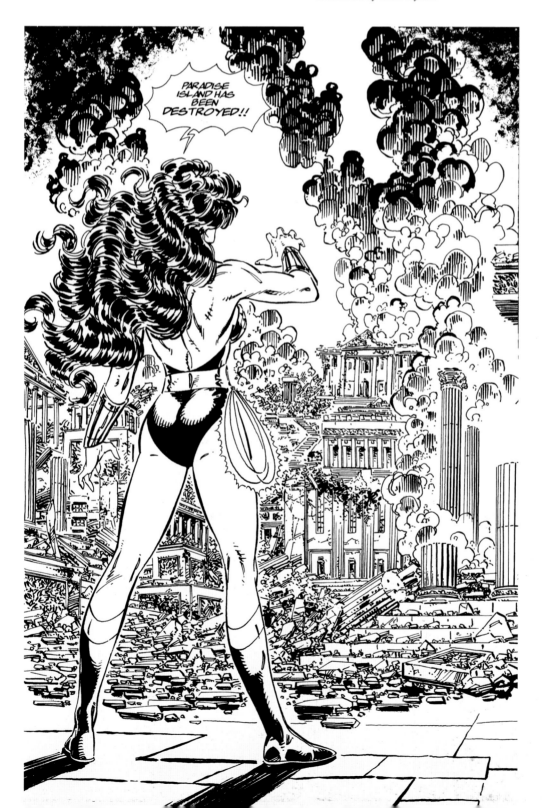

GRAPHIC NOVELS

First, let's try to agree on what a novel, graphic or otherwise, is. The definition in *The Dictionary of Cultural Literacy*—"a long. fictional narration"—is true, but it doesn't really help us much. A novel is not just a short story with glandular problems. It is not achieved by a writer getting inside a short story, putting his back against the last page and shoving.

Here's a simple way to differentiate between the two kinds of fictions. Let's agree with science fiction writer William Tenn that a short story is one in which one thing happens. Logically, then, a novel is a story in which many things happen.

Which means: The novel has more characters, more information about central characters is given, and the reader can witness their personal development. Events can occur over a long time. There is more information about the "world" of the narration, including history and sociology. Finally, a novel should culminate in large consequences, either to the characters, their milieu, or both.

None of this means that the graphic novel writer is exempt from the disciplines mentioned in connection with single-issue stories and especially miniseries. (In fact, miniseries can be considered serialized novels and are often collected in one volume after initial publication.) The narration will probably break down into three "acts" as outlined in Part One and each will culminate in a surprise or new development—a mini-climax—leading to the next section. As always, the action should go up, up, up to provide suspense and sustain interest. Each fight should be tougher than the previous one, each emotional upheaval grimmer, each problem knottier. As with the other forms, there should be no scene that does not contribute to the grand climax, but . . .

You can stretch a bit. The scenes need not be as spare as they would be in shorter stuff. With a hundred pages or more at your disposal, you can allow yourself the luxury of dialogue and event that do not necessarily advance the plot, provided they're amusing and create a fuller sense of personality, era, or place. A subplot or three can be introduced and developed, again with the goal of giving the reader a sense of reality, or to provide contrast to the main action, or perspective on it. Not that subplots, or digressions into history or sociology, are required; if you have a single plot so full of incident and action that it needs a hundred pages to be realized, then start writing and good luck to you. There's no reason a graphic novel can't speed to its climax.

But the novel writer can also adopt an easier pace. I have no way of verifying this, but I suspect novel readers are of a different mind-set than periodical readers. They've bought the book because they like the creators or characters, they've received it as a gift—it's no coincidence that most graphic novels are published after Thanksgiving—or, if they're my age, they're curious as to why them dang funny books are comin' out in hard covers and cost as much as a good dinner at a fancy restaurant. Once the book is in their hands, they have a commitment to it, so you can trust them to stay with you as you introduce character, place, and conflict.

(opposite) A page from Archie Goodwin's script for *Batman: Night Cries,* including a suggested layout.

I am not advising you to use the first fifty pages to start the story's engine. Well-written stories move, regardless of what format they appear in.

Nor should you slight the ending. By the time your tale is done, your readers should have a sense of completion: all conflicts resolved, all questions answered. You should avoid, like dirty handkerchiefs, anticlimax, a term which once meant oversentimentalization and now means explaining plot elements after the emotional interest is exhausted. Old-fashioned detective novels often have long sections in which the investigator explains his brilliant deductions after the local constable has carted the murderer off to the village hoosegow. They aren't much read today. To avoid anticlimaxes, you may have to feed information to the reader as the story progresses, particularly if it has whodunit elements. This isn't easy, but it can be done. A clever writer can let the reader share in the hero's thoughts and conclusions as they occur without necessarily telegraphing his ending and thus spoiling its impact.

Did anyone say that writing is easy?

NIGHT CRIES / Goodwin / 25

PAGE TWENTY-FIVE

1. (Close on Barbara, uncomfortable. Gordon beyond, staring her way)

GORDON: I'm... I'm not sure when it stopped being "Jim."

2. (Barbara whirls, suddenly angry)

BARBARA: Maybe when I stopped being sure what you're
 really doing when you don't come home.

3. (They come together with the bed behind them, Gordon grabbing
 Barbara by wrists or shoulders)

GORDON: God damn it, Barbara! That was one mistake...!
 Years ago...!

GORDON: (2) How much counseling does it take
 before—

BARBARA: Counseling?!

4. (Barbara pushing back at Gordon, breaking his grip. Not quite
 physically fighting, their arguing is on the edge of it)

BARBARA: Do you have any idea how many sessions you've
 missed or cancelled?

BARBARA: (2) Or how it feels being the only
 half of the marriage seeing the
 marriage counselor?

5. (Moving back to the bedroom doorway, a .38 police revolver
 appears, held by someone too close and too shadowy to be seen,
 pointing in toward where Gordon and Barbara argue. It will turn
 out on next page that their son, James, has picked up Gordon's
 own gun)

GORDON: Are you saying I don't care? I had to talk you
 into going in the first place, Barbara! I had to—

PERSON WITH GUN: No!

MAXISERIES

A comic book that's cancelled after one year looks a lot like a 12-issue maxiseries, but it isn't. A short-lived ongoing title may have a dozen wholly separate stories with little or nothing to give them a single identity. But maxiseries, like their smaller cousins, should have a unifying theme and a continuity of plot. However, although they can have 144 pages or more, they need not be as tightly plotted as a novel—they need not be, but they can be. The best of them reach a conclusion that incorporates answers to all the plot and character questions and ties together all the elements, regardless of how diverse they may be. They are clearly single works divided into many sections, not a lot of stories appearing under one title.

To write a maxiseries, apply everything you've learned about miniseries and novels. Each section should advance the story; have a major surprise or plot development; and end with a reason for the reader to buy the next installment.

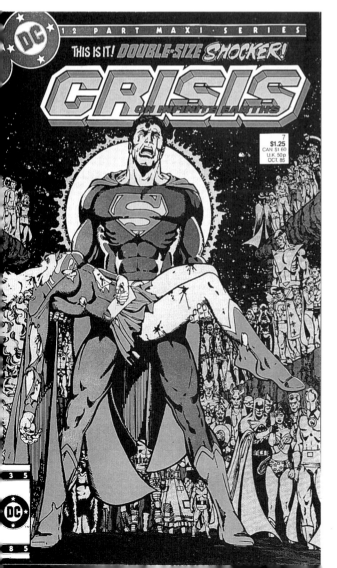

Maxiseries are pretty rare. Fewer of them have been published than any form we have discussed or will discuss. They're hard to do and very hard to do well. But they can be rewarding for both writer and reader. Many experts believe that *The Watchmen,* by Alan Moore and Dave Gibbons, is the *Citizen Kane* of comic art, a work that entertains, innovates, critiques, and defines a genre. It is what comics lovers often give to friends who think that comics are silly amusement for kids and dummies, devoid of literary merit. *The Watchmen* is a maxiseries.

In the 12-issue maxiseries, *Crisis on Infinite Earths,* DC's fictional universe was dramatically altered. Marv Wolfman's saga included the deaths of several established heroes and the annihilation of whole universes—a story whose scope and complexity needed a lot of pages. Art by George Pérez.

(opposite) In his graphic novel, *Batman: Night Cries,* Archie Goodwin used a subplot involving James Gordon's relationship with his wife as a contrast to the main action. Art by Scott Hampton.

When the average, non-comics reading person hears the words "comic book," he thinks of flimsy magazines printed on cheap paper that have been published for decades. They're not wrong, but not wholly right, either.

Actually, only five titles have been in continuous publication since their debut more than 60 years ago: *Action Comics, Superman, Detective Comics, Batman,* and *Wonder Woman.* Of these, four had as lead features just two heroes: *Action* and *Superman* and *Detective* and *Batman.* (I won't insult you by typing the names of those heroes, nor do you need to have an Einsteinian IQ to fathom the name of the third lead character.) A few others have appeared continuously for more than twenty-five years, *Spider-Man, The Fantastic Four, Thor, Iron Man,* and *The X-Men* among them. Yet others, though they are among the earliest comics heroes, went on hiatus for a while, including *The Flash, Green Lantern, Sub-Mariner,* and *Captain America.* By the time you read this, some of the titles/heroes in the list may have, again, suspended publication and others may have emerged from limbo; every few years, it seems, someone tries to revive *Hawkman, Captain Marvel, Dr. Strange, Green Arrow* and *Plastic Man.*

The Superman who appeared in *Action Comics* #1, dated June 1938, and the Superman in whatever issue of *Action* will arrive in your retailer's shop next month, are different critters. Sure, the clothing is similar (though the current super-suit is sleeker) and names of some supporting characters are the same, as are the names of locales (though the first Superman operated in New York, not Metropolis).

But the Superman of the thirties was rougher, brasher, and far less mighty. That wimp could only leap a quarter of a mile, could barely outrace a locomotive and an "exploding shell" might lay him low.

Imagine! The poor dweeb didn't even have X-ray vision. Today's Man of Steel is as powerful in his way as any god in Greek or Norse mythology and, of much greater storytelling consequence, is a fully realized personality, with moments of anguish and uncertainty, capable of loss and defeat as well as triumph.

A landmark—the first issue of *Detective Comics,* the forerunner of modern comic books and their ongoing series. Cover art by Vincent Sullivan.

Superman, and his cohorts Batman and Wonder Woman, have evolved. I'd argue that if they hadn't, they'd long ago have become antique curiosities, not the contemporary, popular creations they are. The magazines in which they appear have also changed. The *Superman* comics of the forties featured the title character in two or three unrelated stories and four or five stories about other characters. Plus a short text piece and several short, humorous fillers. The current *Superman* has only one story—really, less than one, since the stories are almost always continued. That's true of most other comics, too.

Continued stories are the norm; single-issue adventures appear only occasionally, as a change of pace that serves as a kind of punctuation mark between multi-issue pieces or as what publishing folk call a "jumping-on place" to entice potential new readers who might not want to start in the middle of a narrative. Big change, this: Until the proliferation of specialty stores which sell only comics and related items, single-issue stories were not only common, they were all but required; publishers

The powers and abilities of the early Superman were relatively modest. Imagine only being able to leap and eighth of a mile! From *Action Comics* #1. Written by Jerry Siegel and drawn by Joe Shuster.

believed that readers couldn't be sure of getting two consecutive issues—newsstand distribution was erratic at best—and so they wanted everything complete in one issue. Once in a great while, an editor might be allowed to string a narrative over two issues, but never three. Now, six- or seven-issue stories aren't rare, and some editorial teams are willing to push a story into even more pages, not always to the story's benefit.

What all this means to you is that if you hanker to write an ongoing title, youll have to deal with the complexities of continued stories and the problems of continuity they entail. This does not mean you don't have to learn to write a single-issue story using, perhaps, O'Neil's Heavy-Duty, Industrial-Strength Structure for a Single-Issue Comic Book Story. Even Superman had to master jumping those paltry quarter miles before he learned to fly. Well-written single-issue stories incorporate basics you'll apply to every other form. And, to go from the aesthetic to the practical, beginners will probably be assigned a short piece, or several short pieces, before an editor will trust them with anything grander. But let's assume, for the remainder of this section, that an editor believes you to be a Hot Talent and asks you to do the writing chores on an ongoing title. Unless comics publishing changes vastly between now and whenever you get the assignment, you'll have to start thinking in terms of continuity.

There are two approaches to the problems multiple-issue stories present: arcs and what I hereby dub The Levitz Paradigm. Arcs are easier to explain, so we'll start with them.

(opposite) Some 63 years after its debut, *Action Comics* is still going strong. Cover art by Joe Shuster, Wayne Boring, Win Mortimer, Curt Swan, George Kelin, Neal Adams, Nick Cardy, Gil Kane, Kano, and Marlo Alquiza.

Today's version of the Man of Steel is truly super because Superman, like most successful ongoing characters, has been allowed to evolve. From *Superman Forever.* Written by Karl Kesel and illustrated by Tom Grummett and Dennis Rodier.

JUSTICE BE DONE

JSA

JLA

WORLD WAR III

WONDER WOMAN

SECOND GENESIS

JOHN BYRNE

The Sandman

VERTIGO

Neil Gaiman
Marc Hempel
Richard Case
D'Israeli
Teddy Kristiansen
Glyn Dillon
Charles Vess
Dean Ormston
Kevin Nowlan

THE KINDLY ONES

STORY ARCS

Easier to explain because they've already been explained. Let's review the definition given in Part One: A story arc is a story that takes several issues to tell. Anything familiar there? Remember my calling something "a title that has a predetermined number of issues?" Right—that's a miniseries and it is virtually the same thing as a story arc. The difference is that a story arc is part of a continuing series and a miniseries is published as a separate entity. Apart from that, arcs and miniseries are twins and in fact, really good arcs, like minis, are sometimes repackaged as paperback books.

So, if you want to know about arcs, I suggest you review the miniseries section. When doing an arc, it may be slightly more important to remember two things: First, reintroduce characters and locales if they haven't appeared for a few issues when doing an arc, simply because it's easy to forget to do that when you've been writing a series for a while. The writer lives with these fictional people and places; the reader doesn't and, of course, every issue is someone's first—you don't want to confuse, and maybe scare away, a potential loyal fan. New readers should be invited in, given a comfortable chair by a warm fire and made comfortable, not feel as though they've stumbled into an exclusive club where everyone but them knows the secret handshake.

The second thing to bear in mind is that, as with minis and novels, you must have enough plot for the number of pages you intend to fill, another obvious point easily forgotten when you're constantly struggling with deadlines. The editor of an ongoing title isn't as likely to insist on detailed outlines as the editor of a miniseries, so you'll have to discipline yourself to do whatever preparation is desirable.

It wouldn't be accurate to state that arcs are the preferred form for ongoing titles, but in recent years some editors have used them quite successfully. As a writer, you should be aware that they offer the happy possibility, albeit a distant one, of additional income because, remember, they could get reprinted as books.

(opposite) Story arcs that were collected into trade paperbacks.

This could be the situation:

Your editor, the fossil, doesn't like arcs. Thinks they're too fancy, maybe. Thinks they aren't real comics. (Did I mention that he was born before 1950?) He wants you to deliver 12 issues and he insists that many of them contain continued stories. What are your options?

You could give him arcs without calling them arcs. Just dash off three issues of excitement as Captain Wonderful combats the killer robots, be sure to give each a different title, and with your fourth issue, start another adventure.

Or you might conclude a story in two and a half issues and begin another in the last few pages of the third issue. (The 1940s Superman radio program used a similar technique superbly.)

Or you could adopt a structural procedure from our television brethren and conclude your main plot in one, two, three or more issues, but let subplots continue longer—years, maybe. But a caution: Don't use the sub-plots as page-killers. As noted in Part One, subplots have to move, develop, and entertain, just like any other kind of plot.

Or you could adopt the Levitz paradigm. It was developed by the man who is now DC Comics executive vice president and publisher, but was once an editor, and before that a writer, and before that, a fan. Paul Levitz probably thought about what a comic book writer does more than any of his contemporaries, or mine, and during his dozen-plus-years stint as writer of *The Legion of Super-Heroes,* systemized what his predecessors did haphazardly, if at all. Then, as an aid to his own work, he created three versions of the Levitz Grid, which you'll find printed somewhere near this paragraph.

Basically, the procedure is this: The writer has two, three, or even four plots going at once. The main plot—call it Plot A—occupies most of the pages and the characters' energies. The secondary plot—Plot B—functions as a subplot. Plot C and Plot D, if any, are given minimum space and attention—a few panels. As Plot A concludes, Plot B is "promoted"; it becomes Plot A, and Plot C becomes Plot B, and so forth. Thus, there is a constant upward plot progression; each plot develops in interest and complexity as the year's issues appear.

This example of the Levitz paradigm shows typical plotline paths. The only "rule" is that each time a plotline shows up, something must move forward: either new information revealed or development in the character's relationships.

A simplified four-issue breakdown might work like this:

Issue 1: *Plot A:* Killer robots attack a tour bus. Captain Wonderful arrives in time to rescue a herd of vacationers from St. Louis. *Plot B:* Meanwhile, Cap's sidekick, the Groovy Kid, finds a golden waffle iron during a field trip with a second-grade class: *Plot C:* And Cap's kindly mentor, Professor Fondue, sees a comet crash near his suburban laboratory.

Issue 2: Cap learns that the robots are controlled by his old enemy, Mr. Nemesis. He flies to Nemesis's lair, where he is rendered unconscious by a magic crumpet, chained to an obelisk, and dropped into a pool full of man-eating guppies. Meanwhile, the Groovy Kid eats a waffle made with the golden iron and turns into a puddle of maple syrup. On the other side of Generic City, Professor Fondue sees a humanoid whirlwind emerge from the comet. And—introducing Plot D—Cap's girlfriend, Susie, gets an e-mail that causes her to shriek.

Issue 3: Cap escapes from the obelisk—by now, he's had considerable practice at this—clobbers Nemesis and drops the now—inert robots off at the Salvation Army: end of Plot A. Meanwhile . . . an alley cat finds a puddle of syrup lying near a waffle iron and licks its chops: Plot B gets promoted to Plot A. The whirlwind announces its plans to run for mayor: Plot C gets promoted to Plot B. And Susie tells her mom she has to go to Poughkeepsie: Plot D gets promoted to Plot C.

Issue 4: Cap, needing to confer with Groovy, arrives in time to see the cat about to slurp up the syrup, guesses what must have happened to his pal—Cap's had a lot of experience superheroing—and shoos the tabby away; the whirlwind blows his mayoral opponents to Kansas where they're attacked by a scarecrow; and Susie's Poughkeepsie-bound bus enters a space warp somewhere north of Albany.

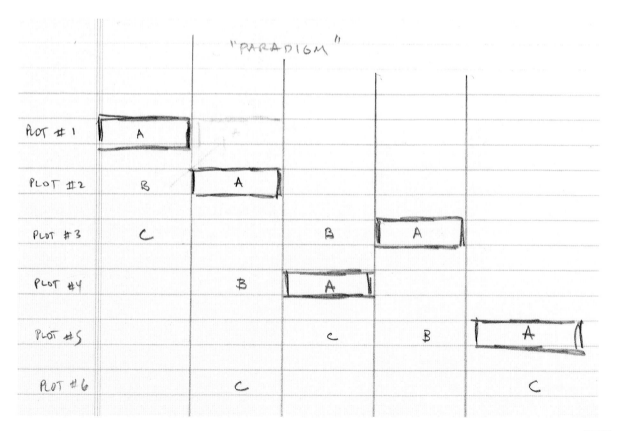

"LEGION"

	#22 "DEAD END"	#23 "BACK HOME IN HELL"	#24 "SUSPICION"	#25 "REVELATION"	#26 "ILLUSION"	#2 "GOI HO
Universo's plot	USES DUPE TO TAKE OUT VIDAR			VIDAR KEPT IN COMA		GIM SUS OF DES
Sensor Girl	SHOWS IGNORANCE OF RECENT EARTH	MON-EL HAS "VISION"	SUSPICIONS FORCE HER TO LEAVE— "EMPTY COSTUME" CLUE	LAST CLUES REVEAL BY EMPRESS	EXPLANATIONS	PROJ AGAI THRO
Mon-el	WORRYING OVER SERUM LIMITS	SERUM WEARS OFF— PHANTOM ZONE	EPILOG			
Violet-Ayla	TALK ABOUT LIVES CHANGING	GROWING CLOSER	AYLA DONE WITH BRIN			
Fatal Five		LOOKING FOR PERSUADER	EMPRESS BUILDING NEW FIVE	LSH SEARCH FOR NEW FIVE	BATTLE— DEATH OF MENTALLA	
Dreamy-Star Boy			DREAMY CHEATING?			BACK TOGE
Return of Garth-Imra				ELEMENT LAD WANTS TO KNOW ABOUT S.GIRL		
White Witch					NEEDED ON SORCERERS' WORLD	UNBIND OF MORD
Element Lad - Shvaugn						Ceremo on Tro
						ELECT FILL ART JU

102

This multi-leveled structure has much in common with the way television soap operas—also known as "serialized dramas"—are constructed. Having three-plus stories running simultaneously is a small insurance policy against boring readers. Someone who once worked on a soap told me that the show's writers were aware that not every viewer liked every character and so they gave each principal time in each episode. Don't care for that slut Carrie, gentle viewer? Wait until after the commercial and you'll see what's happening with that hunk Bernardo. . . . Similarly, the upwardly mobile plot construction outlined above gives readers several characters to be interested in and creates the illusion, if not always the reality, that there's a lot going down . . . the issue's just jam-packed. . . .

It has a couple of additional virtues. It solves the problem of how to entice the reader to buy coming issues—every month, you're giving them at least two suspenseful reasons to learn what happens next. Readers sometimes look for reasons to stop buying a title either because they've found other uses for the money—silly luxuries like food and shelter—or because their interest in comics in general is waning. The end of a story is a perfect "jumping off" place. The obvious tactic is to avoid providing that place.

Another reason to employ the Levitz Paradigm requires us to step, gingerly, from the practical to the philosophical. It seems to me that this storytelling method is the best imitation of life possible in a work of fiction. Life, you may have noticed, does not happen in parcels, but as a continuum. Whatever dramas you're involved in at the moment will eventually stop, but *you* won't, not until that final day, and even then, life will continue, even though you aren't participating in it any longer. So it is with this kind of fiction; it imitates the process of living. One of the reasons we read stories is to imagine ourselves having another existence—heightened, more exciting and fulfilling, but recognizably human. Open-ended fiction facilitates the mental leap from the mundane to the imaginative because it provides the illusion of a world that operates like the world we know and that, I submit, can be deeply satisfying.

Unless it's badly done. Badly done, it's deadly.

A recreation of the grid system Paul Levitz used to track plotlines for *Legion* #22–27. If this had really been the grid used at the time for issue #22, titles and information for the later issues would have been missing or indefinite.

MEGASERIES

That's a term you haven't seen before because I just made it up. I have to call a long continuity that features a single set of characters and appears in several titles *something.* I'm not discussing a maxiseries here; megaseries are far, far more complex and very unusual—you might write comics for 30 years and never participate in one. In fact, to my knowledge, there have been only a handful and they've starred just three heroes, Batman, Spider-Man, and Superman. They were possible because those good guys appear every month in several different magazines. So, although each megaseries has lasted only a year (or less) they've filled a lot more than the 264 story pages that normally comprise a year's worth of any given title. (The most ambitious of them, *No Man's Land,* which appeared in most of the Batman titles during 1999, was a mighty 1,449 pages long.)

Rather than continue giving you generalities, I'll outline a brief case history of the aforementioned *No Man's Land* and then discuss some particulars.

Before we begin, however, you should keep in mind that the *No Man's Land* editorial team had worked on a few earlier megaseries as well as thousands of single-issue stories, arcs, and graphic novels; a megaseries requires a lot of experience, at least from the person or team guiding it.

No Man's Land, hereafter *NML,* began when an associate editor at DC Comics, Jordan B. Gorfinkel, turned a strange idea he had into a 12-page outline. Jordan did this with no prompting from his boss who, I may as well admit, was me. Jordan's premise was this: Gotham City has suffered enormous damage from an earthquake. The federal government realizes that the cost of rebuilding the city would be in the trillions of dollars. A few greedy folk see the possibility of huge profits if the feds don't help rebuild the city and, through bribery and the odd murder or two, convince key legislators to stymie the rehabilitation effort. So the citizens are given the choice of relocating or remaining in an area isolated from the rest of the country. On a given day, bridges and tunnels are blown—Gotham bears an uncanny resemblance to Manhattan—and troops

are stationed to keep anyone from getting in or out.

Not everyone leaves. Criminals see Gotham as a gigantic version of Butch Cassidy's hole-in-the-wall, a mecca for the lawless. There are also a lot of mentally impaired people who just can't manage the exodus, several hundred thousand citizens who refuse to abandon their homes, and a handful of costumed vigilantes who remain behind to protect the innocent and, not incidentally, to reclaim the city.

That was the premise.

Jordan first had to convince me that the story was worth the risks it entailed. I realized that we'd have to commit five of DC's most popular titles to it for an entire year; if we flopped, we'd flop big and that would not endear me to either readers or the gentlefolk who sign our paychecks. But the idea seemed to have tremendous possibilities for drama and nothing exactly like it had ever been done before, anywhere—a seductive lure for a storyteller. So I approved it and sent Jordan's outline to my superiors who, to our happy surprise, also approved it.

Next, Jordan, Scott Peterson, Darren Vincenzo, and I—the Batman editorial team—invited a few select writers to a day-long meeting. We commandeered a conference room, ordered in lunch and refreshments and . . . talked. Story arcs, scenes, themes, personnel, pros and cons—we discussed everything. At the end of eight hours, we had hundreds of notes which became a greatly elaborated version of Jordan's original outline. We made assignments, some of them tentative, and sent everyone off to work.

Then, while the writers were starting their scripts, the editors recruited artists, conferred with

DC's marketing department, and listened to anyone in the DC hierarchy who cared to offer a suggestion. We again revised Jordan's outline. And again and again, as the series progressed and our creative people had fresh ideas. When we were about to begin working on the last third of the story, we realized that our final month's issues would be anticlimactic, devoted to tying up loose ends after the main conflicts were resolved. Two of our writers, Greg Rucka and Devin Grayson, did a final revision, one that produced the most dramatic scenes in the whole series and an unforgettable climax.

Analyze the sprawling behemoth that's *NML* and you discover that it doesn't really sprawl; it falls neatly into three sections—enter our old friend, the three-act structure, with an inciting incident at the beginning of the first and major plot developments at the beginnings of the second and third. In addition to the main plotline, there are about a dozen subplots, which makes the series seem disorganized at first glance, but each has a distinct place in the development of

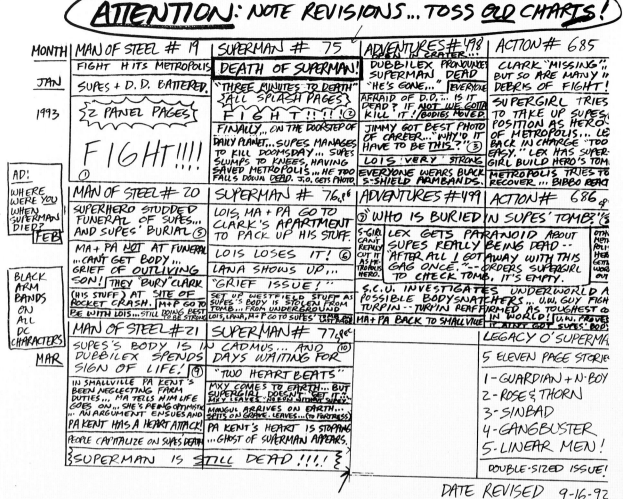

Mike Carlin's chart helped the Superman writers and artists to keep track of plots and subplots during the death of Superman storyline.

the story, either contributing to the central action or elaborating background and characterization. *NML* was as structured as we could make it and still allow for the possibility that our writers and artists might have some good later ideas.

We were also aware that not every potential reader would read every issue and that some would come to the series late. As always, our writers integrated bits of exposition into the ongoing narrative, but we felt that wasn't enough so we borrowed a trick from Prince Valiant. Remember that strip's "Our Story"? Here's our version, printed on the first page of most *NML* issues:

> *. . .and after the earth shattered and the buildings crumbled, the nation abandoned Gotham City. Then only the valiant, the venal, and the insane remained in the place they called No Man's Land . . .*

We felt that even this might not be enough to give newcomers and readers who skipped some issues necessary information about what was happening, so we occasionally printed a color-coded map showing where in the city our principal characters were.

No Man's Land was successful, both critically and financially. It was also complex, challenging, and, for the editors, a bit frightening. A stunt like this is the editorial equivalent of a tight rope walker working without a net. If there had been a flaw in Jordan's original concept, or a contradiction in the plotline, we might not have seen it before too many issues were in print to do a decent reworking—remember, we didn't see the problem with the anticlimactic final third until we were beginning that

part of the continuity. Novelists and film writers can revise before their work is seen by anyone; writers of monthly comic books don't always have that luxury.

Which is why the initial outline is so important. It is absolutely essential that everyone concerned agree on what the story is about and how it will end. It's a little like playing jazz: Once everyone in the band knows the melody, individual performers can improvise, as Greg and Devin did, provided the improvisations contribute to the work as a whole. Even if Greg and Devin hadn't made their final, superb contributions, *NML* would have come to the conclusion we envisioned at that first meeting, though not as effectively.

Everything that applies to arcs, novels, and individual stories applies to megaseries; every scene should point to the climax and no page should be wasted.

The most important aspect of a megaseries is this: The story must justify the space allotted to it. Herman Melville said, "To write a mighty book you must have a mighty theme." If you're going to devote 1,000-plus pages to your narrative, your theme had damn well better be mighty indeed.

As a writer, you should avoid getting drafted into helping with a megaseries unless you're willing to temporarily squash your ego. Your work will be submerged in a vast whole and, if the project succeeds, you'll share the credit with a dozen or more colleagues. But you'll have a satisfaction that's very rare in professional comics writing—you'll have been part of a team, a group of kindred souls, laboring to create something greater than any individual is every likely to achieve alone.

I don't regret the prolonged effort required to participate, as both editor and writer, in *No Man's Land*. But I doubt that I'll ever want to do anything like it again.

A page from *Batman: No Man's Land,* the longest, most complex megaseries to date. Not many words are needed here because the art so perfectly conveys the mood and tone of the story. Script by Bob Gale. Art by Alex Maleev and Wayne Faucher.

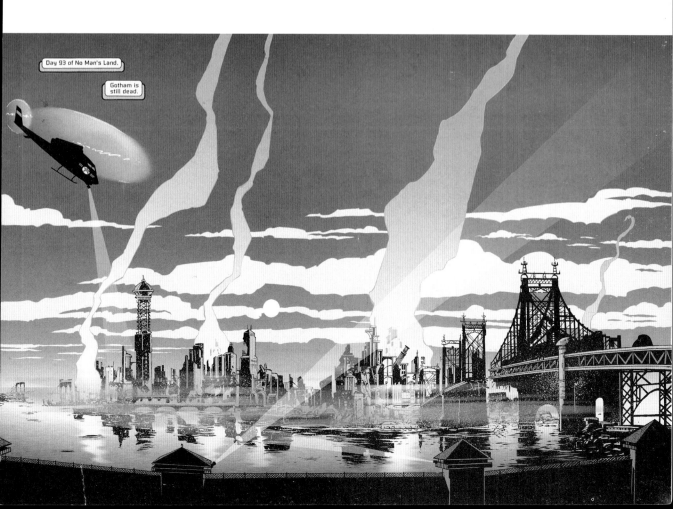

BATMAN: NO MAN'S LAND
Outline by Jordan B. Gorfinkel

PREMISE: Following Cataclysm, Gotham City is declared a complete loss and sealed up. No one goes in, no one comes out. Inside, those citizens who have remained are at the mercy of gangs, ruled by the familiar Batvillains, who fiercely defend their turf and battle each other for supremacy over the city. But James Gordon and Batman are at odd over how to take back the city and must come to terms with who they are, ten years into their partnership with each other and the myriad Batsupporting characters, before they can achieve victory.

GOAL: To reestablish all of the major Batman series characters and situations in a winner takes all "spiritual" successor to BATMAN: YEAR ONE.

At its center, YEAR ONE was the story of the redemption of James Gordon and Batman. Now it's ten years later (in continuity) and Gotham is a crowded place—it's hardly just Gordon and Batman anymore. Gotham teems with supporting personnel, both good guys and bad, superheroic and heroically-super. And yet, at the center of the Batuniverse remain Gordon and Batman. Let's revisit their story—focus on how they've changed in the ten years they've been working together and how they reconcile what they've become (team players) with how they started (lonesome cowboys).

STRUCTURE: This storyline is mega-fiction along the lines of "Knightfall" and "The Death Of Superman." As such, many writers will have a hand in crafting it. Nevertheless, despite its length and scope, it has a definite conclusion. (For all their greatness, "Knightfall" and "Death Of Superman" didn't end conclusively.) As such, we can structure "No Man's Land" in the classical manner, with the rise of the heroes, their setback and their ultimate victory—we can weave an intricate tapestry full of secrets, revelations, defeats, betrayals and, ultimately, a great victory with a subtlety and grandeur that will set a new standard for the kind of mega-fiction tale a monthly series can undertake.

BACKGROUND: During "Aftershock", it became increasingly clear to Bruce Wayne that Gotham was incapable of recovering from the devastating earthquake that rocked the city and Wayne's holdings—primarily Gotham real estate, let's remember. It was sick: the city was buried in rubble, thousands of bodies remained unrecovered and Batman was battling villains like the Riddler, Clayface and Mr. Freeze like nothing had changed.

But something had: Congress, convened for an emergency session to consider the Governor's request that Gotham County be declared a Federal Disaster Area, had lost complete faith that the urban blight known as Gotham City could ever be saved, by the present administration, or anyone, including Superman. After all, the city was more than half empty following the events of Contagion and now Cataclysm killed or chased away millions of its denizens, leaving the place a rotting shell.

The result of the vote was that Congress refused Gotham City Federal disaster relief funds. Adding insult to injury, Congress created a whole new category which it inaugurated with Gotham City: a Federal No Man's Land. (In case you're wondering about the Constitutionality of the law, no one cared enough to challenge it in Federal court.) Gotham City was ordered sealed up and left to destroy itself like a modern Sodom. Citizens were given 24 hours to clear out with whatever they could carry on their backs or be shut in, forever, when the National Guard demolished what remained of its gateways, like the Gotham River crossings.

Gotham City is now completely lawless—it's every man for himself… and every man includes the likes of the Penguin, Scarecrow, Poison Ivy, Killer Croc and, of course, the Joker. Each has taken over a slice of the city and wants to capture the rest, to remake it in his or her own image. The only bastion of civilization remaining, and it's a slim one, is Eastlyn, the home of James Gordon, the former Police Commissioner. Gordon maintains it with an iron hand. He is aided by members of the former GCPD, who rallied behind him on Black Monday, the day the city became No Man's Land, to protect those who remained.

Batman, for those who ever believed he even existed, is a dim memory in the wasteland known as Gotham. No one's seen or heard from him since the day the city was shut in.

THE STORY: It's three months later. The pecking order of the Batvillains is being determined in turf wars all over the city, with no one to stem the tide of evil. Batman returns to take back the city, first as a one man army and then, reluctantly, as the shadowy general of the forces of good. But Batman is conflicted like never before. Indeed, he's having a mid-life crisis—who is he, two decades since his parents' deaths, ten years since he became Batman to fight a solitary war on crime and several years since he took on partners to join him in his battle? And is Gotham even redeemable anymore?

THE CHARACTERS: One of the things readers respond to in stories like "The Long Halloween", and which I think has been somewhat absent in the monthly titles, is definitive characterizations. Even if a character only has two lines in twelve issues, readers want to feel like they know who these people are and that they are important to the story.

I'd like to use the dire circumstances of "No Man's Land" to strip our characters to their essence. Let's play them as strong archetypes, not unlike BATMAN: YEAR ONE did Batman and Gordon. We must go in knowing each character's place in the overall scheme of things, even as we leave it to our writers to determine how they get from a predetermined point A to point B.

Here is my suggested take on each character and the role they might play in "No Man's Land":

JAMES GORDON: I begin with Gordon because he is the soul of Gotham City. Gotham was the source of Gordon's redemption after he left Chicago and he is inextricably linked to her soil. Gordon and Gotham are one, even as Batman and Gotham are one. But while Batman's relationship with Gotham is childlike,

Gordon's is very adult. Batman plays at superhero shtick to be who he is. Gordon needs no such childsplay. He is a straight shooter, by-the-book ex-Marine who suffers no fools, and is as physically tough as he is resolute.

Gordon's built a stronghold in his native Eastlyn, single-handedly holding at bay the corruption that enveloped the rest of the city. Slowly, methodically, with the aid of the majority of the former GCPD, which rallied behind his call to arms on Black Monday, he is taking back the city his own way.

Ironically, Gordon feels recharged in this chaotic atmosphere. It's nice to be bare knuckled hands-on again instead of being Batman's lap dog—wait for Batman to ask for info, give Batman info, Batman disappears before they're done speaking. Batman may respect the hell out of Gordon but Gordon is human—he needs to feel it.

So in our story, when Batman reappears after a three month absence, Gordon is less than thrilled to see the guy. He's been handling things fine on his own. Also, he's ticked that Batman never gave him a heads up about this latest "leave of absence" (let's bring his anger about Jean Paul and Dick taking over the mantle of the Bat on stage). Batman may have been planning behind the scenes and studying the evolving scenario to decide best how to attack, for all Gordon knows, but he doesn't care. What he does know is, this guy disappeared on the eve of Gotham's darkest moment, he's suddenly reappeared and now he expects Gordon to just fall into line? Uh *uh*. Batman's gotta learn that either they're equals or they're on the outs, game over.

BATMAN: The Dark Knight is suffering from a mid-career crisis. He knows he must save Gotham City, but it is not clear how or *why*. Is he saving the city out of altruism? because of his ego? to fulfill a childish fantasy that he can return Gotham to the splendor of his youth, thus recapturing a time of innocence that a thief's gunshots robbed him of two decades past? or even because the fortunes of the Wayne Foundation are dependent primarily on a booming Gotham real estate market?

Moreover, how shall he do it—alone, as the original Dark Knight would have? Or is the Batman "family" that he has developed over time, including Robin, Nightwing and Batgirl(!), an integral, and indispensable, part of his methods?

I am positing that Batman disappeared after Black Monday to complete his plans for taking back the city [see discussion of Batcaves later on]. It was a wrenching decision to leave his city to the forces of chaos for three months. But if "Knightfall" taught him anything, it is to *never* begin a war until you're ready.

THE JOKER: Gotham City, in its anarchic state, is the personification of the Joker, so the Clown Prince is like a knife cutting through butter as he easily rests control of the city from the rest of the Batvillains, quadrant by quadrant. The Joker needs no base of operation; it's clear when he's taken over an area and no one challenges his authority when he does.

POISON IVY: The Quake was like a religious epiphany to Poison Ivy. Gotham City, the ultimate urban blight, is now halfway to being returned to the earth and she has determined that Mother Nature is commanding her to finish the process. Base of operation: Robinson Park.

SCARECROW: The city is like a huge laboratory of subjects already scared half to death. Oh, where to begin! Base of operation: Gotham University.

PENGUIN: Cobblepot is as upset about the state of Gotham City as the forces of good are. If there's no order to upset, what can a fixer like him profit from? So the Penguin becomes a dealer of goods in a city with a finite supply of them. He plays one side against the other with the goal of being on the winning side when the dust finally settles. In the meantime, he's not a guy to cross, particularly if you are in desperate need of medical supplies or a fine Bordeaux. Base of operations: Davenport Towers in Midtown.

TWO-FACE: Two-Face appoints himself Chief Justice of Gotham. He butts into the middle of stalemated turf wars and judges who should win—always so that he himself comes out on top. Base of operations: City Hall/Wall Street.

KILLER CROC: Croc leads the nomadic Street Demonz whose only desire is to loot. He cares not a wit about ruling anything; rather, he craves good sport and good times. Whoa be Gotham City when there's nothing left to plunder. Base of operations: the site of the former Babylon Towers.

CATWOMAN: Honestly, I believe that she would cut her losses and leave Gotham since she has no real emotional attachment to Gotham. Moreover, there's nothing worthwhile to steal, anyway. However, if we need her book to tie in, we'll need to think out a part for her to play that is within character.

ROBIN: The Boy Wonder remains in Gotham County, patrolling the 'Burbs, and waiting for the day to come when Batman calls him back to duty (halfway through the story).

NIGHTWING: Same for Nightwing, who has his hands full in Blüdhaven—the population of this sleepy whaling town nearly doubled on Black Monday when Gothamites fled here. City services are reeling from an epidemic of homelessness and petty theft.

When Batman does finally call on Nightwing to join him in Gotham, Dick isn't sure he wants to go. He's just learned that Batman was in Gotham City during the events of "Prodigal," when Dick took up the Mantle Of the Bat, purportedly because Bruce Wayne needed time off and trusted his ward to watch over his city in his absence. Some trust!

ORACLE: Barbara Gordon remains in her fortified clocktower. She has a network of informers city-wide that enables her to map the shifting rulerships in the city. She is an essential ally to Batman and Gordon in coordinating relief aid and battle tactics.

TITLE/#	ARC	TALENT	A PLOT	SUB-PLOT	MISC
ACT ONE					
JAN.					
NO MAN'S LAND #1 (38 pp)	"No Law and a New Order", 1 of 4	w-Bob Gale; p-Alex Maleev; i-Faucher; Seps-Hollingswo r t h	Introduction, Gotham City As No Man's Land. It's three months since last issue. Oracle narrates tour of sectors, introing villains' status quos (stati quo?)	Establish cops' sector (Tricorner). Conflict over best strategy-attack and expand territory or hold fort and be attacked?	Gordon's Garden-Gordon holds meetings in back yard while tending to a garden that grows through the year. Metaphor for state of the city.
				Gordon and Essen's relationship, as spouses and partners; est. their badgeless authority	Firmly est. Batman as urban myth: "if ever there WAS a Batman, why isn't he here, saving us now?"
				Est. Gordon's distaste for Batman	Issue ends with Batperson sighting (it's Batgirl, in reality)
SOTB 83	Opening, 2 of 4	C-Tony Harris/Jim Royal	Batman returns to rescue undercover agent Alfred. GCPD starts war amongst gangs. Batman confronts Batgirl, a mysterious figure.		
BATMAN 563	Opening, 3 of 4	C-J. Scott Campbell/ Alex Garner	GCPD quells war between gangs, retakes Midtown.	Batgirl meets with Batman in "Batcave" (specifics of location and quantity of Batcaves left ambiguous at this point)	Est. Batman's strategy for retaking city--block by block and by himself. If so, why then does he have Batgirl as his operative? Batman jettison's his modern, "cylinder" belt; replaces it with utilitarian "Year One" pouch style belt, more appropriate to low-tech existence in NML Batgirl: where do villains go when you capture them? Batman: You don't want to know.
TEC 730	Opening, 4 of 4	C-Maleev/Sie n k.	Batman vs. Scarface; Batman learns the folly of setting people free in an anarchic society; comes out during the day for the first time as symbol to the oppressed--I exist, I'm here for you		
FEB.					
LOTDK 116	Scarecrow /Huntress, 1 of 4 : Fear Of Faith	w-Grayson; p-Eaglesham; i-Batt; c-Travis Charest	Batman/Batgirl vs. Scarecrow, based at Gotham U., and with a whole terrified city to experiment on.	Huntress is conflicted about a good (as in not evil) religious leader who takes in former mobsters and converts them to the good side.	Est Huntress sector-one square block around her apartment building, totally deserted; Also est. religious sector that houses all refugees and all religions (clearly we need a liberal to write this one)
				Tensions rise in Gordon sector.	Make sure to show Penguin acquiring something at some point
SOTB 84	Scarecrow /Huntress, 2 of 4	c-Dwayne Turner/Mi k i			
BATMAN 564	Scarecrow /Huntress, 3 of 4	c-Portacio or Hughes			[JUSTICE LEAGUE HOLE HERE]
TEC 731	Scarecrow /Huntress, 4 of 4	c-Eaglesham /Batt		Through detective work, Batman discovers that some gang members he's taken down cannot be accounted for. Where do they go?	
MARCH					
LOTDK 117	Penguin-1 of 2 "Bread and Circuses"	w-Ian Edgington; a, cover, color-D'Israeli; seps-TBD; C-D'Israeli	Est. Penguin as the Fixer. Whether you want fuel or chocolate, you must turn to him. (Story will set up running subplot of Penguin acquiring things.)	Gordon consults mysterious figure whom he both respects and loathes (HE knows it's Two-Face, but we won't find out until end of Act I). They discuss Gordon's growing tension with his neighbors and within own ranks.	
SOTB 85	Penguin-2 of 2	C-McKeever			
BATMAN 565	Blackgate-1 of 2: "Mosaic"	w-Greg Rucka; a-Frank Teran; cover-Teran/Jans o n	Batman vs. Black Mask and gang; Oracle is shocked when she sights the new Batgirl	Lock-up is warden of Blackgate; est. people who beg to be let in since it's only place of order in city	KGBeast is Lock-up's deputy. Appeals to communist, ex-KGB agent in him

Pages from Jordan Gorfinkel's original proposal and subsequent outline for the
Batman: No Man's Land megaseries.

ADAPTATIONS

Comics and motion pictures have always had a kind of symbiotic relationship. Many of the early comic book creators were habitual moviegoers and many Hollywood directors and writers, in turn, read comics. The kinship extended beyond mutual influence: As early as 1940, just two years after Superman made his debut in *Action Comics* #1, he appeared in a series of animated cartoons intended for theaters, produced by the Fleischer brothers, who also brought Popeye The Sailor Man to the screen. Then, throughout the ensuing decade, other comics heroes were given film incarnations, among them Batman, Captain Marvel, Blackhawk, Captain America, Dick Tracy, and Nyoka, the Jungle Girl. (You don't remember Nyoka? For shame . . .)

The movies-comics association continues: Superman, Batman, Steel, the Punisher, the Mask, Mystery Men, the Phantom, and the X-Men have been featured in recent theatrical movies and, as I write this in 2000, a film adaptation of Marvel's Spider-Man is in production.

And what, you may be asking about now, has this mini-history lesson to do with scripting comic books? Not much, except to serve as an introduction to the last kind of writing we'll discuss: the adaptation.

Often, when a big movie that might appeal to comics fans is in the works, a deal will be struck between the film studio and a comic book publisher to do the flick in comic book form. Enter, at that point, the comic book writer, with a potentially daunting job to do.

If you're ever assigned one of these projects, your creativity won't be challenged—after all, someone else provides the story and characters—but there will be demands made on both your professionalism and your craftsmanship. The deadline will be inviolable; the job will have to be done by the release date of the movie—if it isn't, there won't be much point in publishing the comic.

Most movies do their best business the first weekend of their release and are very old news within a month. Unless the movie is a *Star Wars*-size megahit, anyone who might want the comic will want it soon after seeing the movie and so, obviously, the comic will have to be available. You won't have a lot of lead time, either. Movie scripts constantly evolve; you won't even be given anything resembling the movie's shooting script until production begins and as the movie is being made, it will also be revised, sometimes daily. So you'll be sent revised script pages as you do your work, which means that you, too, will have to revise. In the meanwhile, an artist, whose job is much more time-consuming than yours, will be waiting for your version of the script. All of which means, you've got to honor your deadline.

When I've done adaptations, I've begun by estimating how long I'll need to complete the job—usually about three weeks—and then deciding how many pages I'll have to write every day. Once that decision is made, it becomes gospel.

That's the easy part. The rest is probably the best exercise in writing craft imaginable, so good that if you're seeking a way to develop your skills, I suggest you obtain a movie script and do an adap-

tation of it. The experience may be quite educational. It will force you to understand another writer's structure or why, in fact, his script has no structure.

Here's the process: First, define what the story is about—that is, locate the spine. Next, choose which scenes are important. Then, choose which lines of dialogue and bits of action within the scenes are important. You'll also want to decide which lines that aren't integral to the spine of the story are so amusing and memorable that they'll have to be included in the final cut of the movie. (You'll be wrong as often as not, but make the effort anyway.)

At the end of all this choosing, you'll have what amounts to an outline of the script you'll write which includes most of your dialogue—and you'll discover that it's way too long. The average movie script has between 110 and 130 pages; you'll have about 56 pages to tell the same story.

Back to the movie script. Look for places where two scenes can be compressed into one. Then turn your attention to action scenes, particularly chase scenes. On the screen, the two atomic-powered dune buggies whizzing over the roller coaster as Cossacks lob mortar shells at them will have the audience gripping the arms of their chairs, but that won't be true of the same chase rendered in static drawings. Some things movies do better than comics and chases are high on the list. Trust me: You won't achieve the kind of pulse-pounding thrills the movie guys deliver—the excitement mostly comes from movement and your pictures just lie there. So ask yourself what the chase does to advance the plot. The answer will often be that it gets somebody from here to there. You can do that in two panels. If something important happens in the course of the chase, by all means include it, but just enough of it to bring it into the story.

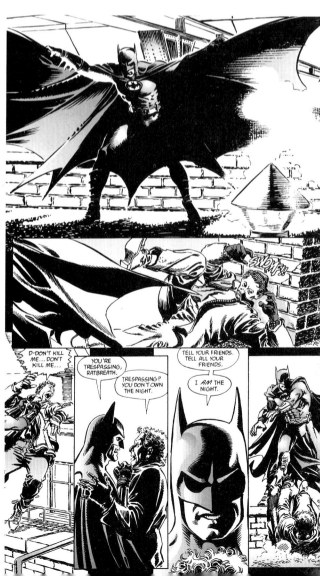

Other kinds of action scenes can often be similarly compressed. In the movie script, the good guys battle six dozen snarling ninjas to achieve entrance into the villain's stronghold. Okay, what does that mean in terms of the plot? Just this: The heroes encounter resistance and get to where they're going. Lose all but three of the ninjas; give the fight a page—it's taken five in the movie script—and you've done all you need to do.

You've cut, compressed, reduced—and you still can't cram the movie into your comic book? Look at the subplots. Are they essential? Can they simply be eliminated altogether? If they involve the star's romance with the leading lady, the answer is no—the leading lady is one of the big attractions of the movie and her character must have a presence in the comic book. But if they aren't essential to the plot, take a deep breath and expel them. They're expendable. They may contain the best writing in the movie, but you need the pages they occupy.

As you've been doing all this, your editor has been sending you the revisions in the movie script. Most of them will be minor. Apply to them

the same selection process that you applied to the original. There will come a point where your script has to go to the penciller and still the revisions will arrive. Well, you're out of time. You've done your best.

Now, presumably, you have a compacted version of the movie script, one short enough to fit into your comic. Begin typing. As you progress, you'll find that you have to rewrite lines and add bits of new dialogue, transitional captions, and an occasional establishing shot. Do these chores sparingly; your task is to approximate the moviegoing experience, not demonstrate your own brilliance by showing the world how the movie script ought to have been written.

This is not the best conceivable way to take a story from one medium to another. Ideally, you'd do what translators of poetry do, rethink the meaning of the original and write it in your own language. Japanese haiku that are translated literally are at worst gibberish and at best flat statements with all the grace and nuance—all the poetry—missing. Japanese is not English and movies are not comics. Each has its peculiar strengths and weaknesses. If you told the story of a movie in comic book terms without trying to imitate the other medium you'd have a better comic book—maybe even a fine one. But that's probably not what the people who've hired you want. They're asking you to get as much of the movie onto the printed page as possible—to remind people who've seen the movie of what an excellent time they had in the theater and to tempt people who haven't seen the movie into the nearest multiplex. That's your job. Do it as well as you can and take a craftsman's pride in the result.

(overleaf and left) Pages from the adaptations of *Batman* and *Batman Returns,* big-screen, big-budget renderings of the Dark Knight. Four of the comic book adaptations have been collected in one paperback book titled *Batman: The Movies.* Script by Dennis O'Neil. Art by Jerry Ordway, Steve Erwin, and José Garcia-Lopez.

CONTINUITY

Continuity is a part of every kind of comics writing we've discussed so far, and a particularly important part of all ongoing series. For some readers—and, I'm afraid, some writers—it's the most important part.

Yet, when I began doing this work some 34 years ago, it wasn't in the comic book writer's vocabulary. It gradually seeped into our consciousness in the late sixties and, a decade later, it was something that demanded almost constant attention. Now, continuity sometimes seems to be what comics writing is all about. That's not only not true, it's a dangerous notion, but we'll save that diatribe for later.

First, what is it?

The word "continuity," as used in comics. television and movies, is actually attached to three different, but related, disciplines. We'll label them Continuity A, Continuity B, and—you guessed it—Continuity C.

Continuity A

This might better be called "consistency." When it's done properly, it insures that everything within the story (or arc or series) remains the same from page to page. issue to issue. A character's name does not change. His hair remains the same color, and is parted on the same side, throughout the story. His car, clothes, apartment, job, hometown, relatives, and friends—everything about him remains consistent unless the plot demands alterations.

In movies, this task belongs to someone whose job title is Script Supervisor and a demanding job it is because movies are usually shot out of sequence; scenes that appear within seconds of each other may have been photographed weeks apart. In comics, it's the task of the editor or assistant editor. When an editor gives an issue a final read-through, immediately prior to shipping it to the printer, he's checking for this kind of continuity.

Continuity B

This is similar to Continuity A, but its scope is larger. It refers to consistency within an entire series, not just a single story. In addition to the consistencies mentioned above, Continuity B is concerned with the backstory and the sequence of important events—in other words, the "history" of important characters and locales which have usually developed over years of publication.

PAGE 8, panel one
 Now on Batman, staring impassively down at Nightwing, Alfred, and Robin. They all look like they're expecting him to say more – especially Nightwing, who has his mouth sort of half open in wonder, as if about to ask a question.

 NO COPY

Page 8, panel two
 And then Nightwing's whole expression changes, his mouth tightening in anger, jaw setting. Batman continues to stare him down.
 If Alfred and Robin are visible in this shot, they're getting out of the way – they've seen Dick and Bruce go toe to toe before, and both wish they were now in Topeka.

 1 NIGHTWING: Okay. Okay, FINE.
 2 NIGHTWING: Nothing CHANGES. You don't need HELP, you've got EVERYTHING under CONTROL. Message RECEIVED.
 3 NIGHTWING: But explain ONE thing to me --

Page 8, panel three
 Nightwing's up in Batman's face now, finger pointing at him accusingly as Batman stares down at him, frowning slightly, but otherwise impassive as ever.

 4 NIGHTWING: -- if you're such a LONER, then why do you let the rest of us hang AROUND? Huh?
 5 NIGHTWING: What are we HERE for? Me and Alfred and Tim and Babs and CASSANDRA now, even, and JEAN PAUL and --

Page 8, panel four
 Batman casually derails Nightwing's rant by handing him a small pawn shop receipt.

 6 NIGHTWING: -- and...
 7 NIGHTWING: What's this?

 8 BATMAN: A RECEIPT for an expensive ATTACHÉ case identifiable as the SENATOR'S—
 9 BATMAN: -- stolen and PAWNED, along with Myles' ELECTRONICS, by four members of the XOSHA gang who robbed his HOUSE.

Page 8, panel five
 You can either go with a CU on Batman here, or get Nightwing in the shot too, to show his entire expression changing to one of confusion and wonder as he holds the receipt and realizes he's sort of getting what he came for after all.
 Batman speaks calmly, matter-of-factly. This isn't even worth getting worked up over, it's just Dick being Dick.

 10 BATMAN: If you're in the mood to FIGHT, why don't you go take it up with THEM?
 11 BATMAN: I've got WORK to do.

 Devin Grayson's preferred script format. The story appeared in the first issue of *Batman: Gotham Knights.*

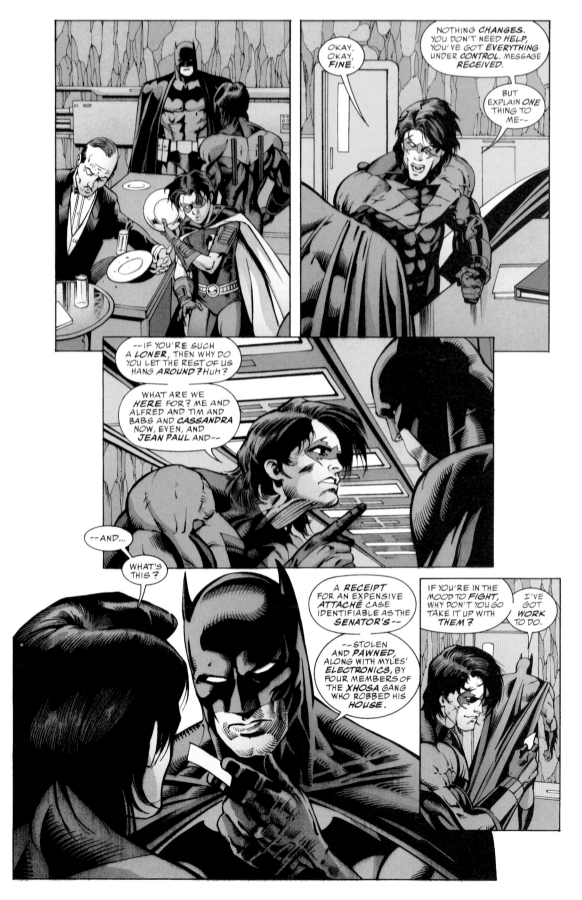

In this *Batman: Gotham Knights* story, Devin Grayson incorporated exposition (the stuff about the attaché case) into an emotional confrontation between Batman and Nightwing. Art by Dale Eaglesham and John Floyd.

Continuity C

This is Continuity B writ large, and applies only to characters who are part of a well-developed fictional "universe," which means, at least for now, only books published by Marvel and DC. It is concerned with the relationships of hundreds of characters and events and a vast chronology that encompasses past, present, and future.

The care and feeding of Continuities B and C are, theoretically, yet another editorial chore. In practice, there is usually someone who has a lifelong devotion to the "universe" and an awesome memory who can be called on to answer continuity questions. This person, nicknamed the "continuity cop," may be a staff member, a freelancer, or even a fan. Although the position is unofficial—nobody is ever hired to be a continuity cop—the service is increasingly necessary.

Maintaining consistency in a single title is demanding and maintaining it in forty titles for a decade or more is Herculean. So why bother? The primary reason is simply that editors and publishers are convinced that modern readers demand it. This wasn't always true. As I mentioned earlier, the first-generation comics writers and editors weren't terribly aware of continuity, and probably never used the word. They were just . . . telling stories. And telling stories in what was considered a transient medium. Until the seventies, the conventional wisdom held that the comic book audience changed every three years. "Comics are for kids," the theory went, "and when the kids discover sports, cars, and the opposite sex, they'll abandon their funnybook habit and give their collection to their younger siblings."

That may never have been completely true, and after comics became an entertainment-of-choice for high school and college students, it stopped being true at all. Gradually, editors became aware that their audiences were far more sophisticated than anyone had previously thought, and that they cared—deeply and, in some cases, almost obsessively. That was an unexpected boon for editors, both financially and artistically. It enabled editors to build reader loyalty—that was the financial gain. The artistic benefit was that it allowed for longer, more complex stories that could continue over several issues; editors could stop worrying about the possibility that a reader would be outraged when asked to spend money on another issue, or three, or six issues, to learn how the story ended. Story arcs, mini-, maxi-, and megaseries would not be possible without the loyalty that continuity created.

Unfortunately, continuity was a mixed blessing. It yielded huge benefits, but it also created problems. Editors and writers who began their comics careers as fans brought their devotion to continuity to their professional lives; they knew all the details about characters and series, but they weren't always concerned with basic storytelling. They sometimes neglected plotting because their interests lay in the minutiae, not in an expertly structured story. Some of them assumed that because they knew series' names, places, relationships, and events, knew these things as well as they knew their own kitchens, that everyone else did, too. So they didn't bother with exposition. The result was that new readers couldn't understand who was who, what was happening, and why. This narrowed the potential audience; a new reader who can't comprehend what the hell all the fuss is about is not likely to make comics reading a habit. After all, he hasn't been entertained, just puzzled, and maybe infuriated.

Another problem: Continuity changes. It has to—with a dozen editors and hundreds of creators working on a fictional universe over ten years, contradictions are bound to occur. And fictional heroes must evolve or become dated and lose younger audiences. Finally, once in a while a writer or editor has an idea for a change in a character's history that makes him stronger, more interesting. For these reasons, continuity must occasionally be updated, either by just changing the story lines without men-

tioning it or by making the changes part of a story line. The result is twofold: First, necessary changes happen and, second, a lot of older fans, who have an emotional investment in the status quo, get angry. Editors are in a classic double-bind. To change or not to change. . . . If they don't, they won't attract new readers and gradually lose their present audience by natural process of attrition. If they do, they aggravate that audience and perhaps lose them faster.

How do editors resolve the dilemma? Any way they can. Where I work, we believe that, in the end, people will always respond to a strong story, though they may initially resist it. So we let the changes happen when we feel they're desirable. Such decisions are always based on educated guesses, and it is possible that we could be wrong. Taking these kinds of chances is part of what an editor gets paid to do.

It is, as the saying goes, a dirty job, but somebody has to do it.

Not much of this will concern you, the writer. But it might be helpful for you to understand why continuity decisions are made, especially if you're ever asked to write a continuity-wrecking script. Like virtually everything else we've discussed, continuity is, finally, a storytelling tool. But it not holy writ.

It's useful to differentiate between the tail and the dog, and remember what should be wagging what.

DENOUEMENT

The bellies are full, the fires banked, the children quiet, and, perhaps, the urge to mate is satisfied. Then comes the beating of the drums and the telling of tales.

Storytelling is probably man's first act of civilization.

No single story, no hundred stories, are very important, a fact useful to remember when that annoying illusion, the ego, tempts us to believe that any one storyteller is important. But storytelling itself—that is deep within our common humanity.

The purpose of all I've written in this little book is to help you tell your stories as well as you can.

Go tell them.

APPENDIX

WRITING HUMOR COMICS
by Mark Evanier

Anyone who's done both will attest: Writing humor comics is a lot more difficult than writing the non-humorous variety. You have all the same challenges—characterization, suspense, story development—that Denny mentions elsewhere in this book. Plus, you have to be funny.

That's the main difference, but it's significant enough that many comic book companies have paid more for a page of "humor comic" script than for one of the adventure or super hero variety.

So how do you make it funny? There are those who say it cannot be taught or learned; that a sense o' humor is something you're either born with or you're not. If you weren't, don't worry. You may still have a lucrative career ahead of you in comics, probably as my editor.

But I've only got so much space here, so let's presume you can tell a joke or, at least, write a joke. And let's hope it's better than this one:

A man walks into a psychiatrist's office and he says, "Doc, you've gotta tell me. Is it possible for a man to be in love with an elephant?"

The psychiatrist says, "Absolutely not."

The man says, "Are you sure? Because this is very important. Please, doctor, look me in the eye and tell me you're absolutely positive that a man cannot be in love with an elephant!"

The psychiatrist says, "I studied at all the finest schools. . . . I have every degree a man in my profession can earn. . . . I'm absolutely, positively certain that a man cannot be in love with an elephant!"

The man sighs, whips out a three-foot piece of jewelry, and says, "In that case, doc, can you tell me where I can get rid of an engagement ring this big?"

Now, I picked that joke for two reasons: One, it's public domain, its author having perished sometime during the Byzantine Era. Secondly, its punch line involves a funny visual. That's one of your missions when you write a humor comic book: Create funny visuals. This joke would probably play better in a comic book because you could actually see the big diamond ring. You could also see the psychiatrist's shocked reaction . . . and, depending on my mood, I might even call for the artist to draw a lovesick elephant peeking in the window.

Funny dialogue is fine in its place. (Tip: The first mistake of the beginning comedy writer is to try and make everything funny. Whatever merits our example joke has would be lost if one attempted to insert gags into the setup. The doctor has to be played absolutely straight so that his dignity stands in contrast to the silliness of the punch line. And the man's urgent problem must be treated as a dire matter. . . . again, to contrast with the silliness of the punch line. If you tried to give funny dialogue to either, you'd weaken the contrast. "Contrast" is a good word to keep in mind throughout any kind of writing but especially comedy writing.)

Funny dialogue, however, is an enhancement for funny visuals, not a substitute. You want to give

(opposite) From *Sergio Aragonés Destroys DC.* Script by Mark Evanier and art by Sergio Aragonés.

the artist, even if you're the artist, something funny to draw. However, that leads to another problem, which is to not telegraph the punch line—i.e., not to let the audience/reader know what's coming before you're ready.

If you're telling someone a joke, you generally don't want them to get to the payoff prematurely . . . but it's also important not to rush so quickly to the end that you don't set things up fully. In our model joke, the man asks his desperate question twice. If he only asked it once, his plight wouldn't seem so urgent; ergo, it wouldn't seem as much a contrast—there's that word again—when we discover what it's all about.

A joke can also go on too long. If I had more room in this piece, I might have had him ask three

times—that would really point up his urgency and build us up for the payoff—but I don't think I'd stretch it out any longer than that. I'd risk the audience getting bored and distracted or—worse—figuring out what's coming before we deliver the kicker.

In a mystery story, you might like the idea of the audience figuring out whodunit before your hero tells them. That can be desirable, just as long as they don't figure it out too early. But when you're telling a joke, you usually don't want them to realize where you're going before you get there.

In a comic book, there's a very real danger of your reader seeing that visual punchline before they've digested the entire setup. After all, it's right there on the page and readers tend to at least glance at the artwork for the entire page before they plow into the word balloons. If they do . . . well, have you ever heard a real amateur joke-teller who puts the punchline before the setup? ("This guy walks into a psychiatrist's office with a huge engagement ring he bought for an elephant and asks if it's possible for a man to be in love with . . .")

One way to avoid tipping the joke too soon is to try and lay out the panels so the payoff line isn't on the same page as the setup. If this were occurring in the middle of a story, I might end page 8 with the patient saying, "In that case, doc . . ." Then the first panel on page 9 would be our first glimpse of the huge ring and the rest of the man's dialogue. Unfortunately, you can't always arrange for the page breaks to fall where you'd like them.

One thing to keep in mind is that people read the lettering left-to-right and their eyes tend to scan across a picture the same way. In this case, I'd arrange the final panel with the patient on the left and I'd call for the angle to favor him and the huge ring. Then we'd put the psychiatrist to his right, so we see the ring and then we see the reaction to it. (Important point: The amateur humorist would leave the psychiatrist out of the panel, figuring to focus on the guy delivering the punchline. Bi-i-ig mistake. The doctor's reaction is another potentially funny visual and it's the punctuation to the joke.)

So you include the doc and you put him to the right of the patient. If you do it the other way around, the panel's time sequence is backwards: The readers will be seeing the psychiatrist's reaction a split-second before the event that triggers it. And if I were going to include that lovesick elephant—and it might be too much, but it might not—she would certainly go on the far right, as a kind of topper.

But that's just the way I'd do it. In comics—and especially in comedy—what works works and what doesn't doesn't. As I learned writing for standup comedians, if the audience doesn't laugh at it, you throw it out, no matter how funny it seems on paper or how well it adheres to any given set of "rules."

That's one frustration of the craft. Another is that you never seem to have enough room to take your time and fully develop each setup/punchline combo. You find yourself having to shorthand . . . to do in ten words what you'd rather do in a hundred. I find I never have enough room to say all that I want to say . . .

. . . not in most comic books and certainly not in this article. *Ciao!*

From *Fanboy* #6. Script by Mark Evanier and art by Sergio Aragonés and Steve Rude.

THIS ONE'S PROBABLY UNDER THE LEGAL MINIMUM SIZE! I'LL HAVE TO THROW HIM BACK!

WONDER WOMAN! I'M YOUR BIGGEST FAN IN THE WHOLE WIDE WORLD! I HAVE *EVERY* COMIC BOOK YOU'VE EVER BEEN IN!

I'VE EVEN *READ* SOME OF THEM! EVEN DURING ALL THOSE YEARS WHEN IT WAS REALLY CRUMMY!

IF THAT DOESN'T PROVE TRUE LOVE, I DON'T KNOW WHAT DOES!

HEY,...ISN'T THERE SOME RULE THAT SAYS NO MAN CAN SET FOOT HERE ON PARADISE ISLAND?

YES,...*MAN!* IT DOESN'T APPLY TO COMIC BOOK READERS OR OTHER GUYS WHO DON'T DATE!

THAT'S NOT TRUE! I HAVE WOMEN SURROUNDING ME, NIGHT AND DAY!

YEAH. ME, SUPERGIRL, CATWOMAN, BLACK CANARY,...

SHE'S EVERYTHING I DREAMED OF IN A WOMAN... AND MORE! SHE'S EVEN INKED WELL!

IF I COULD GET HER TO GO TO THE DANCE WITH ME...

OH, WOULDN'T *THAT* BE SOMETHING? I CAN SEE IT ALL NOW--

--ALL THAT ENVY... EVERYONE'S EYES POPPING OUT LIKE A TEX AVERY CARTOON STARRING MARTY FELDMAN...

15

THE COMIC BOOK WRITER'S LIBRARY

First, the obvious. If you want to understand comics, you must read comics. I won't presume to give you something like a greatest hits list because, frankly, I don't want to risk offending friends and colleagues by omitting work they consider worthy. But in any comics specialty store, you'll find whatever's new and popular as well as a selection of collections and graphic novels. Bookstores, both online and the old-fashioned steel-and-concrete variety, can also probably help you.

Below, I've listed non-comics books that I've found interesting, useful, or both. Each has something to say, directly or indirectly, about the visual telling of stories.

Screenplay—Syd Field
Field gives the best explanation of the three-act structure that I've ever read.

Adventures in the Screen Trade—
William Goldman
As noted earlier, this is where I first encountered the idea of a story spine. In addition to being of interest to writers, it's a wonderfully entertaining look at the movie business.

Hitchcock—Truffaut
For fifty hours, François Truffaut talked to Alfred Hitchcock about Hitchcock's craft and art. This is a transcription of that conversation, with photos added, and there may be no better primer on visual narrative.

Writing to Sell—Scott Meredith
Out of print, but perhaps still available from rare book venues both on- and offline, this is a good, basic text for commercial story-tellers.

Comics and Sequential Art—Will Eisner

Graphic Storytelling—Will Eisner
Eisner is as good an artist, in every sense of the word, as comics have had. He's also a good teacher. I'd consider both these books, but particularly the second one, required reading for any comic book writer.

Understanding Comics—Scott McCloud
Anyone who really wants to understand the medium, thoroughly, has to read this incredible, 216-page comic book. Like Will Eisner's books, it is required reading.

Reinventing Comics—Scott McCloud
This is not so much a sequel to McCloud's earlier book as an addition to it. The author explains how comics have come to be where they are in the first section and discusses the future in the second.

McLuhan for Beginners—
W. Terrence Gordon
Comics are part of that big, misunderstood monster we label "the media" and McLuhan thought more deeply about media, probably, than anyone. I find his own books hard

going, but Gordon's text—which is, coincidentally, in faux comic book form—presents his ideas clearly and concisely. It may help you understand the unique appeal of comic books. You might want to read it in conjunction with McCloud's *Understanding Comics*. If you'd like to try reading McLuhan himself, you might be able to find a copy of his magnum opus, *Understanding Media*.

The Writer's Journey—Christopher Vogler

Vogler takes Joseph Campbell's ideas about mythology and applies them to screenwriting. Although ostensibly for movie folk, the book's central theses are also pertinent to comics writers. People with a general interest in mythology will also be able to learn from it.

Story—Robert McKee

Another book directed at screenwriters that comics writers will find enormously useful. McKee, who is probably the world's premier teacher of screenwriting, looks at plot, characterization, and story structure from every angle. If you're not lucky enough to take his course, you can consider this book the next best thing. If you have taken the course, the book constitutes the best class notes you can imagine.

Man of Two Worlds: My Life in Science Fiction and Comics—Julius Schwartz and Brian M. Thomsen

This is not about writing, but it is the story of one of the most influential and important editors comics have ever had, and so should be of uncommon interest to anyone involved in the field.

INDEX